LAWYERS

AND

JUSTICE

DAUMIER

LAWYERS
AND
JUSTICE

Preface by

JULIEN CAIN

Member of the Institut de France

BOSTON BOOK AND ART, PUBLISHER

LC # 70-162324

SBN 8435-2009-4

Translated from the French by Arnold Rosin

DAUMIER
AND
LAWYERS AND JUSTICE

TO choose a great artist's production in order to show one of its aspects is always a thankless and often painful task. When we deal with Victor Hugo or with Honoré de Balzac, we hesitate and proceed cautiously for fear of betraying them. It is a similar feeling that overtakes the historian and critic on the threshold of Daumier's *œuvre*. How can we possibly make a choice from that mass of works, even with the help of scholarly studies: Jean Laran and the curators of the Cabinet des Estampes who have accurately classified so many scattered works; Loys Delteil who has managed to collect almost four thousand lithographs in ten volumes; Eugène Bouvy who has collected in two volumes about a thousand wood engravings, plates and vignettes? There is no lack of anthologies grouping Daumier's most famous lithographs, ranging from the amusing to the sublime, from a multiform, almost mythical personage like his Robert Macaire to the King of Naples, the famous 'King Bomba', gazing from his palace window upon the corpse-strewn courtyard which led Michelet to say: 'Your *Best of Kings* comes straight from Tacitus: terrible and sublime . . .'

For a more accurate idea of the caricaturist's manner and of the artist's technique, it is preferable to study a group of works dating from the same period and sharing a common theme.

In this manner, our attention will easily be focussed on the essential, no longer thwarted by the constant effort which must be made, consciously or not, when shifting from one subject to another. The eye—which registers and compares—can then function at its best.

This factor alone gives special value to the selection of lithographs presented here whose unity is at once evident. These thirty-nine plates appeared separately in *Le Charivari* between 1845 and 1848. But they have a common theme which is not only the setting of the Palais de Justice and the lawyers' robes but also their attitude towards their 'victims' as revealed in their expressions and gestures. Here Honoré Daumier is the passionate and pitiless witness of the lively or silent scenes in which he portrays the 'physiology' of the Man of Law.

With pencil only, he tries to present what so many pamphleteers and clever writers had offered in the *Physiologies* which were then becoming increasingly popular. Aubert, the publisher of *La Caricature* and brother-in-law of Charles Philipon, the editor of this weekly paper, published some hundred and fifty small, yellow-bound books illustrated with wood engravings by some of the most famous illustrators of the day. Imitators were not lacking. The expressions of social life, the portrait of various social classes and professions are here often mediocre but sometimes accurate. One day we will have to explore to the full this literary genre which, though limited, nevertheless characterizes a period when the reign of the bourgeoisie was well established, when small trades catered to special needs and acquired a new form, a period when the Parisian believed himself to be a king. As a reaction to Romanticism, these *Physiologies* revealed a literary realism which was to triumph as early as 1850. Already it included Champfleury and Duranty, but the originator was Balzac.

The word had been made fashionable by Brillat-Savarin, whose *Physiologie du goût* dates from 1825. In 1826 Balzac wrote his first *Physiologie du mariage* which is a kind of pre-original of the one published in 1829 and which, in 1846, found its place in the *Comédie humaine* where it was an important work. In 1841, however, Balzac did not think it beneath him to offer a *Physiologie de l'employé* illustrated by Trimolet for Aubert's and Lavigne's small collection. *Physiologie, monographie, anatomie:* he remembered these scholarly terms to which others could be added, such as *Code* or *Prolégomène,* and he used them as titles for short and often insignificant works introduced in *La Caricature* or *La Silhouette* in 1830 and 1831. In 1841 he returned to this kind of writing in newspapers such as *La vie parisienne* and in publications such as *Les Français peints par eux-mêmes* or *Le diable à Paris.* We know that he was preparing monographs on the Priest and the Cabinet Member as well as an *Anatomie des corps enseignants* which certainly would have been racy. This borrowing from science—a borrowing both naïve and deliberate—of a restricted vocabulary did not fail to impress the reader. This method, later to be used by the Naturalists and other literary schools, enabled

the author to generalize from characteristics observed in a small number of individuals.

Although Honoré Daumier, through the power of his art, stood head and shoulders above the finest illustrators of his time: Charlet, Traviès, Grandville, Bertall, Henri Monnier, Decamps, and even Gavarni, we should not forget that he too was imbued with the rather limited viewpoint of these *Physiologies*. How could the young draughtsman help but take the subject matter and inspiration from that common source when, in 1831, at the age of twenty-three he joined the group of *La Caricature* which in hundreds of lithographs was to interpret the daily events of these historic years? He himself illustrated several *Physiologies* in Aubert's collection: the Door-keeper, the Stroller, the Poet, the Musician, the Schoolboy, the Social Lion, the Swindler, the *Rentier,* and of course that of Robert Macaire, but the image of the famous adventurer who became minister was banned by the censor. Daumier certainly was familiar with the *Physiologie de l'Homme de loi* which appeared in the same collection by a 'writer' with vignettes by Trimolet and Maurisset. There is no doubt that he remembered passages showing a client pursued by a briefless lawyer 'forever running after trials' and who 'wastes his time in the waiting hall pacing up and down from ten o'clock until four. We see him in every chamber of the Palais de Justice, civil and criminal alike, peddling huge blank briefs which he holds beneath the sleeve of his robe'. Here is the 'Devil's Advocate', a sort of judicial rag-picker, with his squint, his greasy beard and his bibulous nose, who picks up the dirty, dishonorable, foul briefs which his more honorable colleagues had kicked into the gutter or thrown to the prison vermin. But here is 'the lawyer of the civil courts, king of chicanery, the lion of the Palais de Justice; he is no lawyer but a gentleman of law . . . He despises his colleague of the criminal courts and fails to return his greeting . . . After ten or fifteen years of practice, he sells a hundred thousand francs' worth of words a year'. The brotherhood of lawyers is a recognized law; there is no such thing as 'interfering with a friend's client, being the friend of the client alone. The client is property, land, factory, an income in the flesh . . . If two colleagues are to be on harmonious terms with each other, they must be opponents in the same case. Once they have joined battle it becomes for them a real fight to the bitter end . . . After the hearing the two opponents meet in the robing room, clasp hands and leave to dine together at the *Bœuf à la Mode* or at the *Veau qui tette*'.

The faces of the public prosecutor, the president, the judges, the clerk and the bailiff are all drawn with the same vigor. But 'chicanery is never discussed

without mentioning the attorney-at-law, for in the judicial hierarchy his position is precisely the same as that of the broker in the financial hierarchy. He is the Croesus of the law courts'. As for the notary, he is a 'theatrical personage who appears in almost every act of the comedy of life just before the curtain falls'. He appears in the 'matrimonial farce' when he presents 'the goose-quill pen to the dove who signs the warrant condemning her to marriage for life'. And the same is true of the 'death drama' and of the purchase or sale of goods and property.

Daumier himself was familiar with this 'magic lantern of black figures'. When he was about thirteen he knew and frequented the Palais de Justice because his father, Jean-Baptiste, an artisan from Marseilles and an unrecognized, misunderstood poet (despite fleeting renown in the wake of his tragedy *Philippe II* and the publication of poems dedicated to Louis XVIII) came to Paris and turned to lawyers in an attempt to settle his affairs. At an early age Daumier worked as an office boy for a bailiff, then as a book-assistant and later as an apprentice to a lithographer. Several years earlier, from 1816 to 1819, young Honoré de Balzac, whose father hoped he would become an attorney-at-law or a notary, went through a training stage first with Maître Guillonet de Merville, then with Maître Passy.

After a period of trial and error, a major event, the July Revolution, caused the young man, then just twenty-two years old, to turn to political satire. Because of the unusual opportunities it offered and the almost unlimited development which he conferred upon mediocre people, as well as the sordid scenes he described, he established himself as one of the most feared enemies of the new regime. He was brought to trial in 1831 for his *Gargantua* and with his publishers Delaporte and Aubert was condemned to six months' imprisonment which he served the following year at Sainte-Pélagie. He devoted himself to the 'Movement Party', passionately following street unrest and the legal debates which ensued, including not only the great trial of April 1834 which led to the destruction of the republican party and the ruin of Fieschi and his accomplices, but others as well.

Judges and lawyers appear in Daumier's work as early as 1832. Among the satirical caricatures, one of the most cruel is that of the lawyer Dupin the elder. The following year he portrayed Gaudry and Lecomte, judges at the civil court of Versailles, the public prosecutor Plougoulm, with his dreadful blubber lip, and the other public prosecutor Jaquinet-Godart. The judge, pointing to the dead republican, is saying: 'This one can be set free.'

In 1836 the government instituted a strict Press censorship which affected drawings, engravings, lithographs and prints 'regardless of their nature'. To

quote Armand Carrel, 'newspapers have to be their own censors and resign themselves to the situation'. Daumier likewise resigned himself to the situation. Political satire was forbidden, as was also to be the case in the aftermath of December 2 and again immediately after the Commune. So he turned to lampooning bourgeois life, the legal world being a particularly fruitful field for ridicule. In the vignettes which he made in 1836 for the *Chronique de Paris* (Bouvy, Nos. 84-89), the tone has already changed and is now less sarcastic. Here is the Salle des Pas Perdus, 'the entrance to the lair where chicanery jumbles the threads of its own quibbling'; here is the greedy lawyer squeezing his client after the hearing where he has just lost his case. 'What can I possible do about it? . . . Perhaps there is a way out . . . Look, send me a hundred écus tomorrow.' The irony is monstrous when Robert Macaire as a lawyer pleads with Bertrand in his prison cell. This irony grows bitter when it exposes the lawyers' daily tricks and stratagems. Nothing escapes Daumier's merciless scrutiny, not even the setting: the law courts, its furniture, its officials, least of all those whose most furtive gestures he seizes in the course of his daily observation. He wanders from one courtroom to another, pausing even in the humble Court of Conciliation where the housewife, basket in hand, stands among the crowd of litigants. This is one of his illustrations for the article published in 1841 by Émile Dufour on *Le Défenseur officieux en justice de paix* in Curmer's *Les Français peints par eux-mêmes*. Already the types are well established. This one, 'always with a five-franc hat on his head, wears a coat of an undefinable colour but which more often than not must have been black, and his hand, with a grey or brown floss-silk glove, amorously caresses a faded ruffle flecked with yellow spots, revealing the man's addiction to snuff. Always and everywhere he carries under his arm an enormous bundle of court proceedings together with a heavy *Neuf Codes* in octavo. These are generally the only papers in his files and the only book in his library. He always walks quickly and appears busy. To see him so occupied in the midst of the constant hurly-burly of Paris we would think he were overwhelmed with cases'. There are many stages in the careers of these men, but for all of them 'chicanery is both happiness and a way of life. They would die the day after they cease scribbling on official paper and deciphering the hieroglyphics of legal documents'.

Daumier thus became gradually familiar with 'the mysteries of a mass of miserable affairs and the deplorable spectacle of reasonable people allowing themselves to become involved in them'. In the same volume is the article signed by de Balzac on the Notary. 'If the notary does not have the impassive

and gently rounded face familiar to you, if he fails to offer society the huge guarantee of his own mediocrity, if he is not the well-geared cog in the legal machine which he ought to be, if his heart harbours the slightest element of anything artistic, capricious or loveable, he is finished. Sooner or later he takes the wrong turning, goes bankrupt and before very long is lying in a grave. He leaves behind the regrets of a few friends, his clients' money and freedom for his wife.' Daumier could very well have illustrated these famous lines and it is often a source of lasting regret that the two artists failed to collaborate.

Daumier occupies only a minor position among the countless illustrators of Balzac: a total of four plates in the Furne-Hetzel edition which appeared between 1843 and 1848. These include two unforgettable figures, that of Ferragus, with both hands on his cane, and that of Père Goriot, with the words: 'Some felt horror when they saw him, others pity.'

Although Balzac remarked of Daumier 'This boy has something of the talent of a Michelangelo', he preferred more docile artists or those enamoured of a more literal form of truth. Despite the fact that they shared the same professional observation of human beings and the art of emphasizing their essential characteristics, the two *Comédies humaines* developed on different levels.

Here must be emphasized what distinguishes and even separates Honoré de Balzac from Honoré Daumier. 'The immensity of a project which embraces both history and the criticism of society, the analysis of its evils and the discussion of its moving principles, entitles me, I believe, to confer the title of *Comédie humaine* on the work published today.' These words conclude the preface of July 1842 when Balzac at last found the appropriate collective title for the *œuvre* to which he had devoted the previous thirteen years. Honoré Daumier's intention was entirely different. He wanted his *Comédie humaine* to be merely 'a kind of satirical fresco of the bourgeoisie in the first half of the nineteenth century.' This is how Champfleury defines it in his *Histoire de la Caricature moderne*. 'This work is a pageant of men in power, magistrates, industrialists and inventors, whether men or women. At the same time it is the comical portrait of Paris and the Parisians both at work and play.' Three important classes, however, are missing: the clergy, the army and the nobility. For Daumier wanted to be above all 'the ordinary satirical painter to the constitutional government' and was 'condemned thereby to portray merely the bourgeoisie'. This distinction appears in the picture that both artist and novelist have given us of law and its functionaries.

The *Comédie humaine* reveals a rich knowledge of law which Balzac sees as

the basis of society. He respects justice and even wants it rendered with the pomp it deserves. In *Une Ténébreuse Affaire* he regrets the fact that 'everywhere, even in Paris, the shabbiness of the setting, the poor arrangement of the courts and their lack of decoration diminish, in a nation of the most theatrical and vainglorious monuments, the influence of its enormous power'. Although there are some sordid and dubious characters among the lawyers who figure in his *Comédie humaine,* he gives a generous place to men of integrity such as Judge Popinot in *L'Interdiction,* the attorney-at-law Deville in *Gobseck* and *Père Goriot,* the notary Mathias in *Le Contrat de mariage,* magistrates such as Monsieur de Grandville in *Splendeurs et Misères des Courtisanes,* all of whom are devoted to their duties and to the causes they defend.

Here we are far indeed from the unattractive figures of the *Physiologies* which Daumier remembered and used as types.

This thorough apprenticeship prepared Daumier for the time when he undertook a series devoted to lawyers and justice in which all the variety of his art would be seen. It was created ten years after *Robert Macaire* (1836), and after *Histoire ancienne, Caricatures du jour* (1843), *Voyage en Chine, Bas-Bleus, Étrangers à Paris,* and *Philanthropes du jour* (1844).

Never had he such command of technique. 'We must not judge it', Jean Laran rightly insists, 'only by the state of *Le Charivari* rather heavily printed on third-rate paper where the text shows through the paper. Fortunately, Aubert, the publisher, made an excellent print on white paper which was carefully put aside, then used the stone for *Le Charivari.* When a series was complete . . . it was made into an album.' More precious still are the rare proofs before the actual printed text was added 'carefully printed for the artist and his friends on fine white or delicately pink tinted wove paper'. In these one really sees 'the stone at its finest, with all its force and delicacy'.

These years (1845-1848), during which Daumier produced his *Pastorales, Actualités, Baigneuses* and above all his *Bons Bourgeois,* mark the core of his intense production imposed by the number and the variety of works required by the press. This constant, unremitting activity would have exhausted any other artist, but as Daumier remarked: 'I keep on going.' Far from exhausting him, it stimulated him, unleashing new forces and pointing the way to new horizons. In his passionate search for plastic expression, he took to modeling busts as a better means of grasping the form before even making a pencil drawing. Although he was soon to turn to painting, his canvases are unfortunately all too few in number but invariably striking in quality. This experimentation

gives the work of the period a kind of completeness, his pencil 'splashing sunbeams on the stone'.

Baudelaire, the greatest art critic of the day, was fully aware of Daumier's genius. In his celebrated study 'Some French Caricaturists' written in 1857 and later to become part of his *Curiosités esthétiques,* he emphasized the fact that Daumier's drawing 'is colored naturally. His lithographs and wood engravings create the idea of color. His pencil drawings contain something more than the black which outlines the form. He conveys the idea both of color and thought. This is the mark of outstanding artistry'. Twelve years earlier in his 1845 Salon, the young Baudelaire had assigned Daumier a place in his artistic pantheon. 'In Paris there are only two men who draw as well as Monsieur Delacroix, the first in a similar manner, the other in quite the opposite. The first is Monsieur Daumier, the caricaturist, the other Monsieur Ingres, the great painter and shrewd admirer of Raphael. This assertion will certainly amaze their friends and enemies, their supporters and opponents alike, but after careful and studious attention, it will be obvious to all that these three *drawings,* though different, have this in common: they render perfectly and completely that aspect of nature which they set out to render and each expresses what it wishes to express, exactly and no more. If one prefers sane and robust qualities to the strange and surprising abilities of a great genius plagued by his genius, then one might even say that Daumier draws better than Delacroix. However, should one's preference be for laborious finesse rather than the harmony of the whole and the character of the composition, then one might say that Monsieur Ingres, enamoured of detail as he is, draws better than either of them . . . but after all, what is to prevent us admiring all three?'

We must accept the critics' lyricism when they had to express in words their impression of the lithographer's *œuvre* and which still impresses anyone who recognizes the power of black and white. From his palette, Daumier will add pale blues and pink tones to an ochre and sepia background, yet it remains the same art, a mysterious product created in a style independent of the schools then in favor, either that of Delacroix or of Ingres, and which escapes definition even when Michelangelo, Rubens and Géricault are mentioned in comparison.

Law and Justice is one of Daumier's most important and characteristic series. The silhouettes are truly 'modeled in the black tones of the lithography'. The composition is arranged around the figures with such natural order that the decor scarcely matters, reduced as it is to benches, tables, grilled doors, a wall, all indicated with a few lines and little light. The faces and bodies, however, are in the full light and each scene is emphasized by a strong gesture. Here hands play an important role, even if the fingers are merely sketched.

Magistrates are portrayed with a certain restraint. Some are attentive, others are filled with sceptical, disillusioned dignity and a kind of elemental laziness which lulls them to sleep. (Plate 16.) Here we are again in the world of the *Physiologie*. 'In order to protect himself from the lawyers' quibbles and innuendoes, the judge rarely listens and deliberately often allows himself to fall into what may be called the sleep of the just. Only the president feels obliged to remain awake.' But even he falls asleep (Plate 11) . . . Certainly we cannot expect anyone whose career has developed in an atmosphere of intrigue to become interested in justice. This is why so many magistrates 'judge little and sleep much. Their existence is one long sleep during which they advance with great strides, like sleepwalkers, along the smooth and flowery path of nepotism'. But though Daumier finds them somewhat ridiculous, he spares them and would have agreed with these words from César Birotteau: 'The older, more bent-over and white-haired the magistrate is, the more solemnly he carries out his priestly function.' Justice, however, is poorly delivered and the Republican Daumier suffers from this. He has seen what careful observers had noted in their learned works. Tocqueville estimated that from 1827 to 1841 the ratio of offenders to citizens had increased to three in seventeen. A real 'criminal army' arose (which, through Eugène Sue, even found its way into literature), arising from an ever-spreading poverty whose increase kept pace with that of public wealth and the amassing of new private fortunes. It was during this period that Victor Hugo wrote *Les Misères,* which was almost finished by 1847 and later became *Les Misérables*. In 1834 he had already written *Claude Gueux* in which the murderer is portrayed as an unfortunate creature rather than as a criminal. In *Le Dernier Jour d'un condamné* he stated: 'This disease, namely crime, will one day have its doctors to replace your judges.' Daumier is the true illustrator of Victor Hugo, the Hugo of Jean Valjean, when the judge (Plate 15), sprawled in his armchair, says to the accused who is pushed forward by a gendarme: 'You were hungry . . . you were hungry . . . that's no excuse . . . I am hungry practically every day yet I don't go out stealing!'

The lawyer is apparently insensitive to this poverty. He defrauds the unfortunate souls, whether guilty or not, plaintiffs or defendants, who place their hopes in him. It is this game that outrages Daumier even more than the judge's indifference.

Some, including Baudelaire, have compared Daumier to Molière. And the Goncourt brothers declared that 'never since Rabelais have the rascally tribe of quibblers been so hard pressed, more eagerly hounded and their dishonest tricks, impertinence and effrontery so ruthlessly dissected. With burning hatred Daumier sketched the countless types of excited lawyers, the mocking, unrelenting or slumbering judges, and the exasperated litigants'. Henri Focillon had an entirely different view expressed in terms which summon to mind his heart-rending impression after seeing not only this series, but also the painting in the Phillips Memorial Gallery of three chatting and laughing lawyers, behind whom are portrayed a weeping woman and a gendarme.

'In addition to the lawyer's manner and variety, his professional tricks, his tragedian's tears (while the crowd listens attentively, rigid with fear and curiosity), what impressed Daumier in such strange places where, in the ponderous tones of an outdated literary manner, men pass judgement on business interests and on the emotions and freedom of others, is the sterile poetry of the setting, the ray of sunshine which outlines a triangle of light on a dusty wall, the funeral eloquence of black robes and white collars, and finally the contrast between the pompous voice of the attorney for the defense and the infinite variety and unpretentious humanity of the accused.'

In Daumier's drawings tragedy and comedy are thus mutually attracted, complementing and mingling to create a many-sided view of lawyers, and indeed of every kind of lawyer, whether it be the sham lawyer, the one who seduces his female clients or the 'spellbinder'. In contrast to the latter with his feline, dried-up face, he portrays the greasy, sensual-looking lawyer wrapped in his large robe. Here the painter betrays his admiration for Rubens, in the free manner in which he expresses himself. If each of these figures were analyzed and compared, we would recognize Daumier's contemporaries as well as Daumier himself who, for example, is represented in Plate 3 and perhaps also in Plate 8 in the slightly bent forward lawyer. We discover the 'forceful and generous facial expression', described by Théodore de Banville, 'the small piercing eyes, the nose turned up as though by a gust of idealism, the fine, generous, wide-open mouth, in short, the entire fine head of an artist who so strikingly resembled the bourgeois whom he painted'.

It is a pity that below such fine lithographs we find captions which, in the words of Jean Laran, 'are always unpleasant to the eye and whose text is often irritating'. We know a great deal about the captions in Daumier's lithographs. Albert Wolff, for example, relates how when he was a young man Louis Huart had forced him to find five cent captions (a hundred sous each) for Daumier's lithographs—'this was the standard price'—and he insisted that 'these simple captions, which did more for him than did his art, were in no way his own'. Some and we will quote them, are lively and witty. 'As for Daumier', Jules Claretie wrote, 'he was content merely with drawing'. Théodore de Banville gives a delightful description of him in his studio on the Quai d'Anjou on the Ile Saint-Louis, orking on several stones at the same time with stumps of lithographic pencils which were so small that they could no longer be sharpened; 'and it is to this habit of using stumps that Daumier owes something of the strength and boldness of his drawing in which the heavy, lively line is of the same quality as that of his shadows and hatching'.

Champfleury, among the most discerning of his contemporaries and the first in his *Histoire de la Caricature moderne,* fully realized that Daumier 'needed a stimulating presence beside him'. 'Behind Daumier I see Philipon prompting him with venomous captions and constantly dictating the subjects. This is what differentiates him above all from Grandville, who has political ideas but can only express them with difficulty. Daumier's role is in the pure realm of art . . . If the captions are removed from the plates, there still remains a colored spot, a composition that belongs to the realm of art.'

Sometimes this stimulation comes from afar and higher still, whether from the angry or hopeful Parisian populace or from a writer like Michelet. In the 1850's the two men met frequently. The famous plate entitled 'The Reverend Capuchin Friar Gorenflot taking over from Monsieur Michelet during a history lecture at the Collège de France' appeared in *Le Charivari* shortly after *Lawyers and Justice.* Two days later, on March 30, 1851, Michelet wrote to him: 'Several have their own merits, but you alone possess vigour. It is through you that the people will find the means to speak to the people.' Did he help him? It appears so when we read: 'I will give you my captions as they are ready. I have a fine Cossack series to do. The Cossack is the factotum of the North, a second-hand dealer on horseback.'

But with censorship reinstated, things again became difficult. On December 23, Michelet wrote to Daumier: 'I am following you every day and my admiration never stops growing. When you were inspired politically, I better understood

19

the strength of your limitless production. Now though you have lost everything you are still the same, showing that genius is a world complete in itself.'

Indeed, Daumier began to feel more and more restricted. We know that he was never entirely free, even in the newspapers which made him famous.

In 1862 Baudelaire wrote to his publisher Poulet-Malassis: 'Think of Daumier free and kicked out of *Le Charivari* in the middle of the month and only paid for half the month.' Yet fifteen years earlier Philipon had not hesitated to turn down finished plates when he thought they repeated previously used themes. In 1851 *Le Charivari* published four important lithographs, *Lawyers and Litigants,* forming a sequel to *Lawyers and Justice*. With the last of these, portraying two lawyers in conversation ('Don't forget to make a reply to my plea, and I shall reply to your reply . . . that will mean two more speeches for our clients to pay for . . .') Daumier's lithographs on the theme of justice come to an end.

Yet, as Daumier the painter, he continually returns to the subject. He had greater freedom now than when inhibited not only by the imposed caption, but also by the impatient printers. This resulted in a number of powerful paintings first discovered by a mere handful of art lovers, including the *Deux Avocats* in the Musée de Lyon, and watercolors similar to those described by the Goncourt brothers in their *Journal* on March 13, 1865. 'Walking down the Rue Laffitte the other day, I noticed some extraordinary watercolours by Daumier depicting panathenaean judiciary lawyers meeting one another, judges walking by, against the obscure background of an examining magistrate's dismal office or of a corridor in the Palais de Justice. These are done with an India Ink wash and in a fantastically ghostly manner. The hideous heads gloat with dreadful joviality. The men in black have an indescribable ugliness of horrible ancient masks in a record office. The smiling lawyers look like corybants and there is something of the faun in the grim macabre lawyers.'

Daumier the illustrator continued to use the precious repertoire which as a draughtsman he had gradually accumulated, as is evident in the numerous pencil and pen and ink sketches. This is obvious from the wood engravings published in Eugène Bouvy's second volume. The *Croquis variés* of 1853 (Nos. 844-849) are pure caricatures—huge heads on dwarfs' bodies—so that the lawyers' expressions are all the more striking, especially in 'A Vulture and Two Pigeons'. Several years later, in 1864, Daumier expressed himself in an altogether fresh manner, the line drawings (Nos. 956-959) being true portraits drawn with great skill and care. When on the occasion of the 1867 Exhibition, *Paris-Guide* turned to the great men of the day such as Victor Hugo, Sainte-Beuve, Théophile

Gautier, Renan and Michelet as well as to Ingres, Barye and Puvis de Chavannes, Daumier too was called upon to illustrate the article devoted to the Palais de Justice (No. 71). And again we see a lawyer seated on his bench in the monograph which the 'Galerie contemporaine' in 1877 devoted to Daumier (No. 987). A few months before his death, when the great artist had to give up work on account of failing eyesight, his friends organized an exhibition of his work at Durand-Ruel's. Particularly striking were the canvases he had devoted to the Palais de Justice. They made a deep impression on Gambetta, the famous lawyer, and their realism did not go unnoticed by writers and critics such as Philippe Burty, Camille Pelletan and Marius Vachon whose articles expressed their true feelings. In his article of April 25 in *La France,* Vachon concluded with the following words which we hope will prove to be prophetic: 'We are convinced that a reproduction whether photographic or otherwise of the forty or fifty drawings devoted to lawyers would have great success at the Palais and elsewhere.'

More than a century later they have lost none of their vigor and power. Every time we take a fresh look at these plates and study them closely, we realize that Daumier was a powerful artist whose personages, silhouettes, expressions and gestures of every kind leave a deep imprint on our minds. Satire, the enemy of gross exaggeration, avoids anything that might appear monstruous, but thanks to Daumier's draughtsmanship acquires the highest degree of expression and becomes a means of introspection, revealing the innermost being of each individual. Satire can do even more. Paul Valéry was well aware that 'with Daumier ridicule is a kind of rehearsal for the Last Judgement and all his caricatures give the impression of a moral or intellectual Dance of Death'. Thus in this series portraying the unworthy servants of Justice, satire has indeed passed judgement and has condemned them for posterity.

Julien CAIN

Member of the Institut de France

PLATES

No 1

— *Beaten, Sir ... beaten on all counts ... yet this morning you told me I had an excellent case.*
— *Yes, damnit ... and I am ready to handle your appeal ... but I must warn you, I never take a case to the Royal Court (Appeal Court) for less than three hundred francs.*

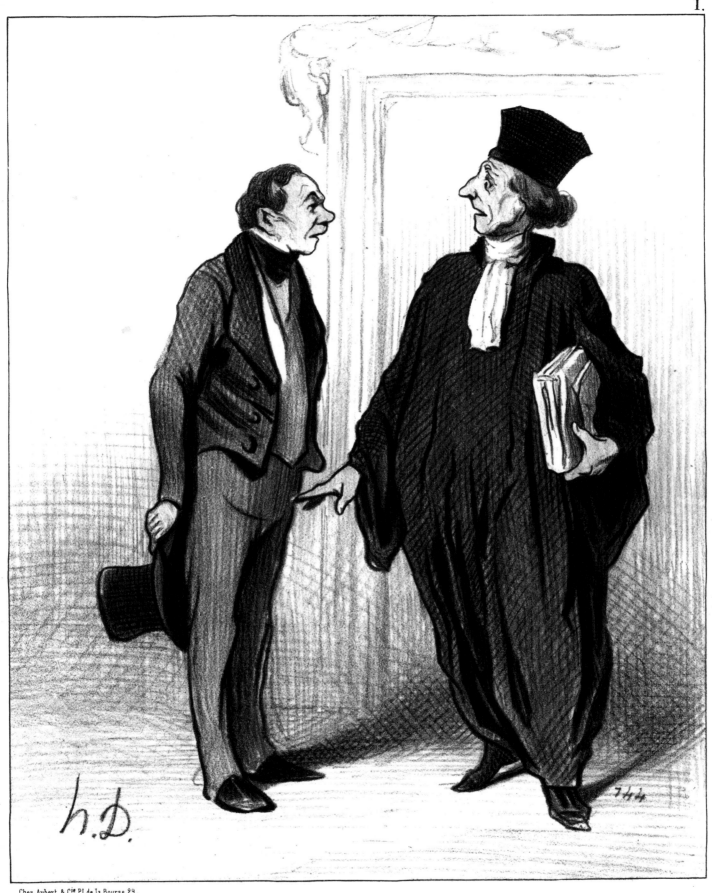

— Perdu, monsieur... perdu sur tous les points..... et vous me disiez encore ce matin que
ma cause était excellente!...

— Parbleu....je suis encore tout prêt à le soutenir si vous voulez en appeler.... mais je vous
préviens qu'en Cour royale je ne le soutiens pas à moins de cent écus!....

No 2

— *Taken possession of, item one water jug, containing no water . . .*

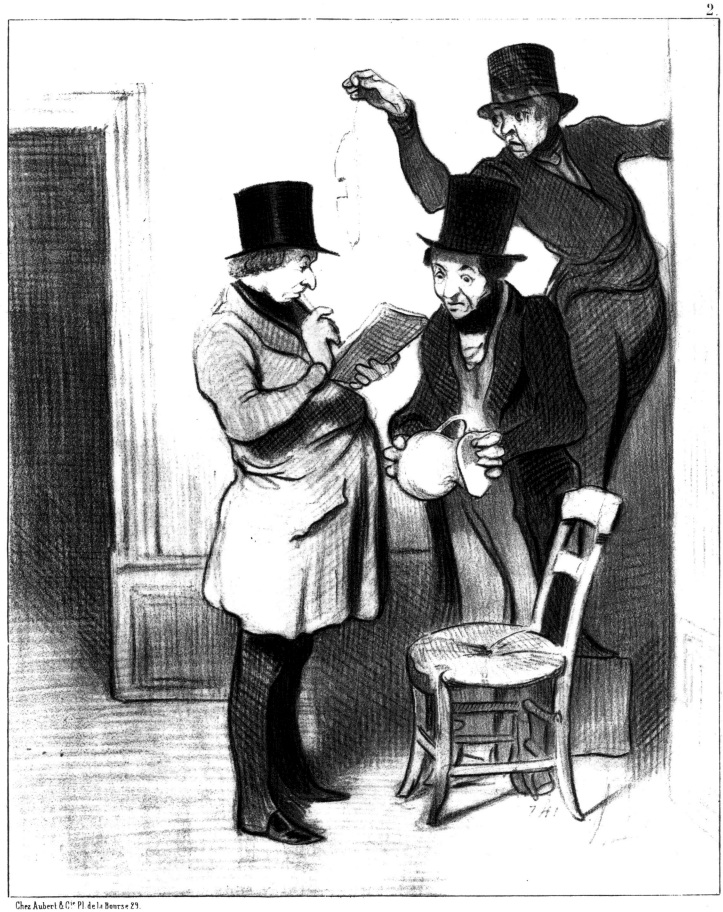

— Avons saisi dito..... un pot à eau, sans eau.....

No 3

No close season for this sort of game.

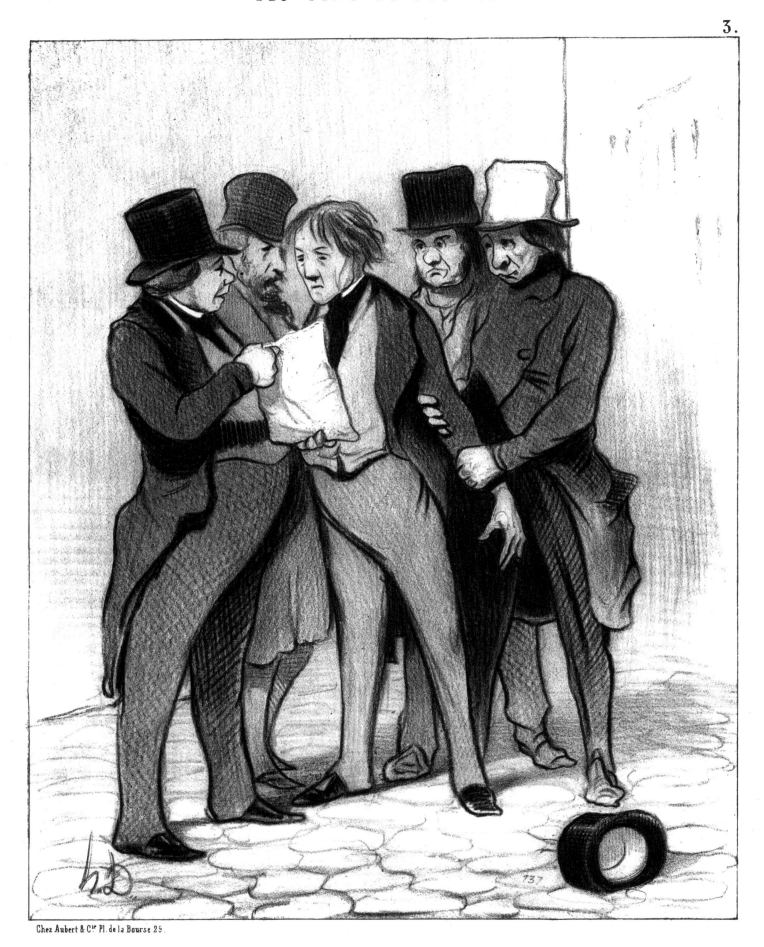

Chez Aubert & Cie Pl. de la Bourse 25.

Gibier qui peut être chassé en toutes les saisons.

No 4

— *The Court having weighed the evidence and apportioned the advantage accruing from the dereliction, abrogates the appeal and all similar procedures, discharges the appellant and amends the judgement of the lower court in respect to the costs of the respondent, with the exception of a forfeiture payment to Advocate Bizotin in respect of the final judgement, and hereby dismisses both parties as aforementioned.*
— *Gad, what a verdict My lawyer will want at least seventy-five francs to explain it to me*

Chez Aubert. Pl. de la Bourse, 29

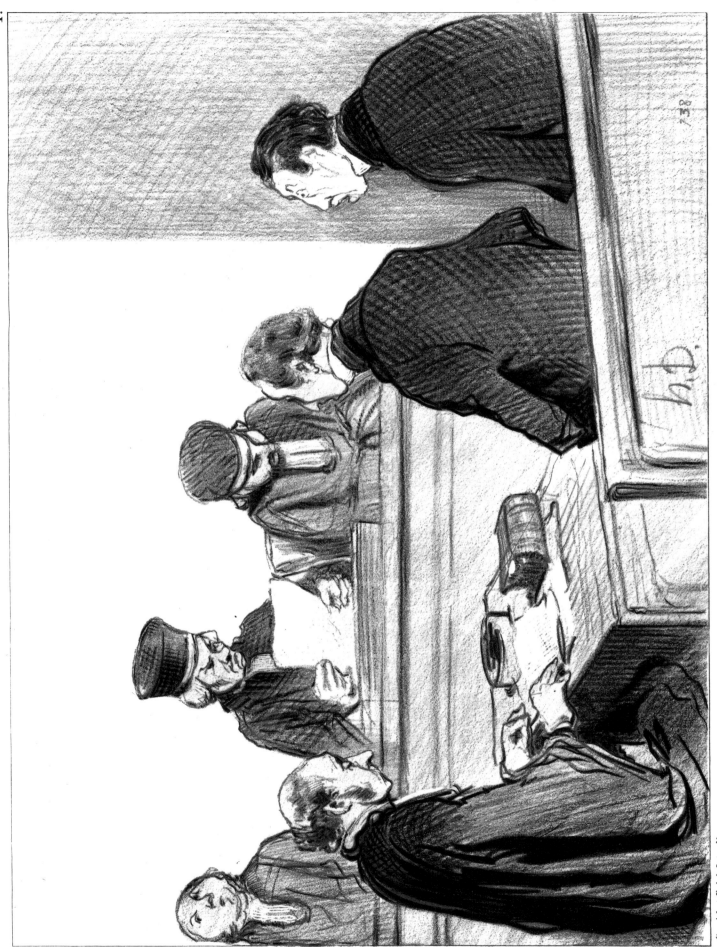

— « La cour, vidant le délibéré, et adjugeant le profit du défaut, met l'appellation, et ce dont est appel au néant, emendant quant à ce, corrigeant réformant la sentence des premiers juges, décharge l'appelant, condamne l'intimé aux dépens de l'incident, dont distraction au profit de Mᵉ Bizotin avoué, qui la requiert pour le surplus des fins de la demande, met les parties hors de cause et les renvoie dos à dos, dépens compensés »........

— Saperlotte quel jugement !.... mon avoué va me demander au moins soixante quinze francs pour m'expliquer la chose !........

No 5

— *Can you prepare a letter that will soften his heart?*
— *Soften the heart of a bailiff. . . . You must be a foreigner, my good fellow!*

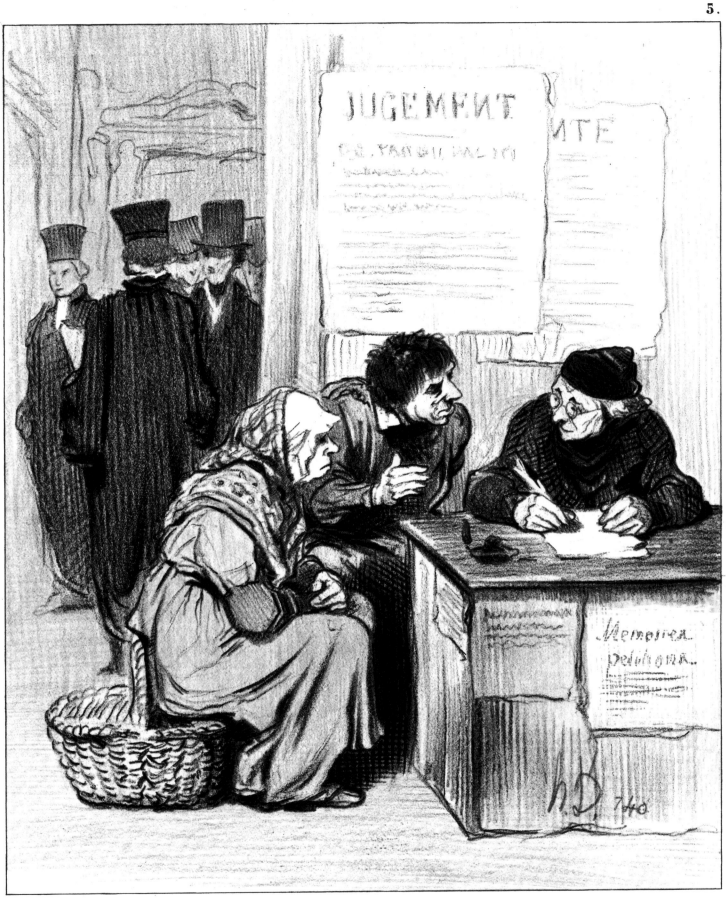

—Faut-y faire une lettre pour l'attendrir?....

—Attendrir un huissier!.. vous n'êtes donc pas français, mon brave homme?...

No 6

A lawyer who is evidently profoundly convinced ... that his client will pay him well.

LES GENS DE JUSTICE

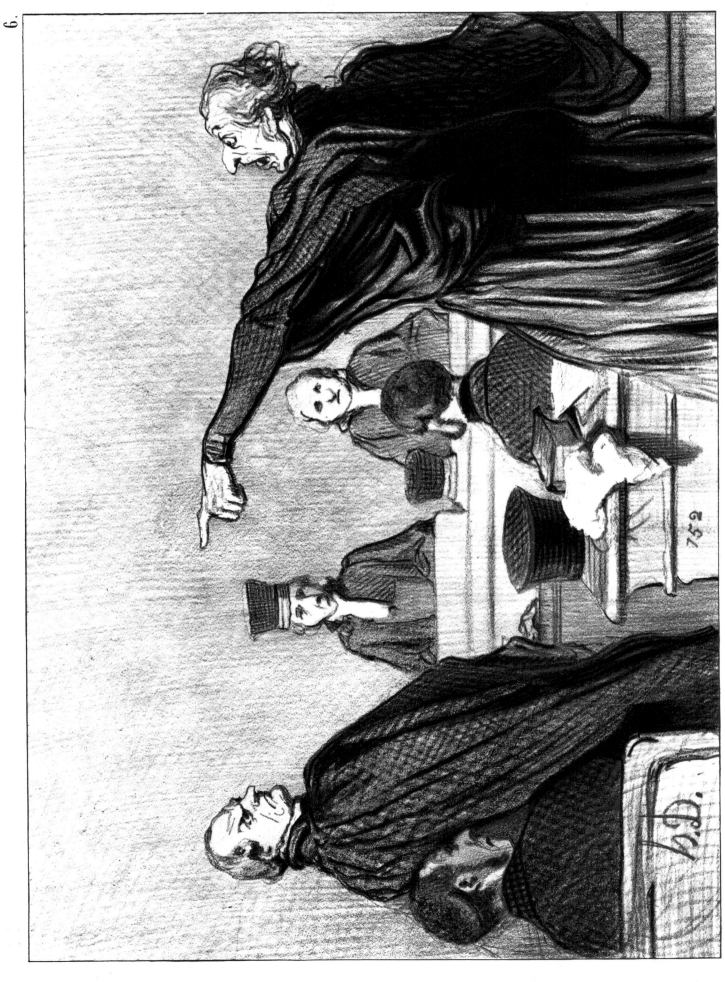

Un avocat qui évidemment est rempli de la conviction la plus intime............ que son client. le paiera bien.

— *Come, come, my dear colleagues... no disputations out of court... this waiting-room is where clients waste their time.... not where lawyers waste their breath...*

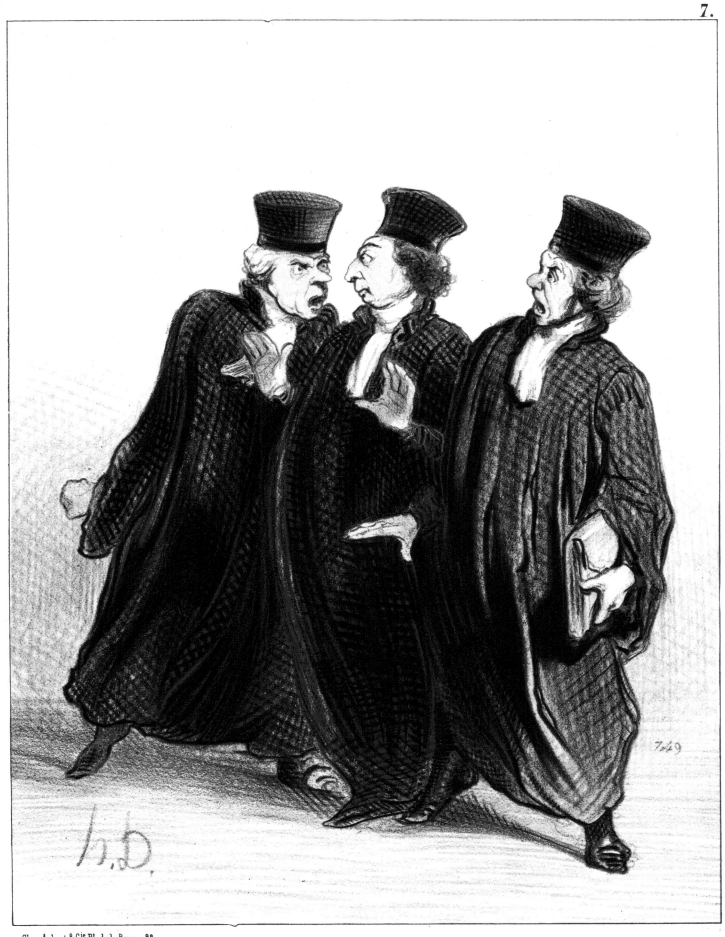

Chez Aubert & Cie Pl. de la Bourse 29.

— Allons donc, chers confrères.... vous avez tort de vous disputer hors de l'audience..... ce lieu ci doit être la **salle des pas perdus** pour les plaideurs.... mais jamais les avocats ne doivent y perdre des paroles......

— *I really gave you a good dressing down...*
— *And I didn't mince matters in my reply...*
— *We were both excellent...*
— *We were superb. It's only in the Palace of Justice that people really know how to argue and call each other all manner of names without getting angry...*

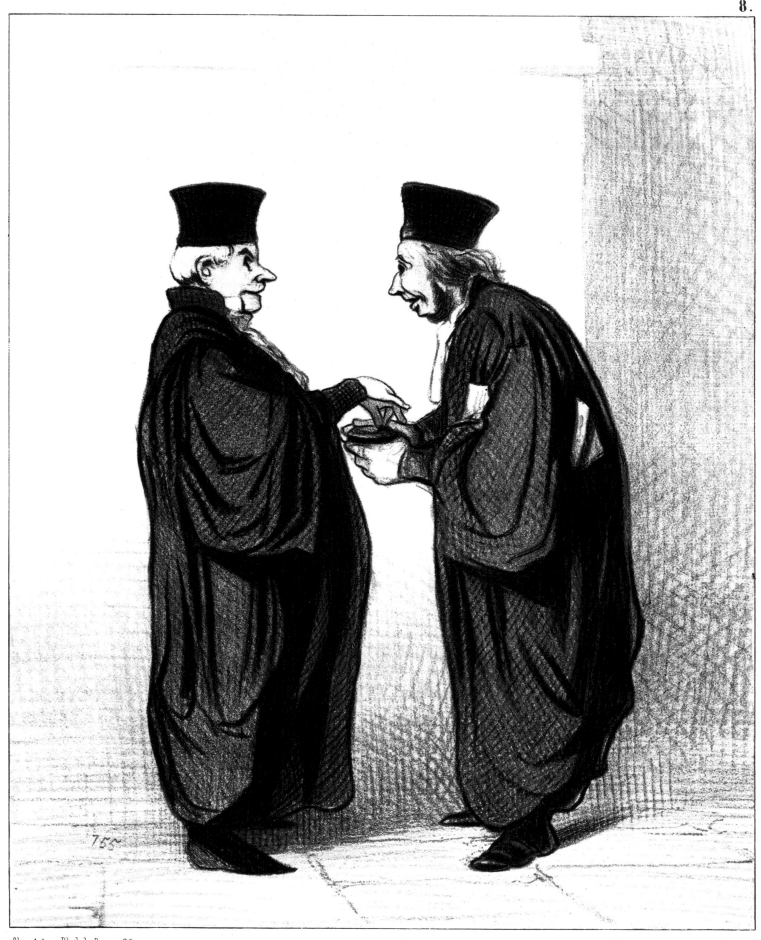

 — Comme je vous ai bien dit vertement votre fait !...

 — Mais aussi, que je vous ai cruement riposté les choses les plus désagréables !...

 — Nous avons été beaux !...

 — Nous avons été magnifiques !.. Ce n'est réellement qu'au Palais qu'on connait la manière de se disputer
et de s'en dire de toutes les couleurs sans se fâcher !...

— *You insulted me in your address to the Court, but I shall oblige you to give me satisfaction....*
— *Sir, rest assured you do not frighten me!.. I have sufficient civic courage never to rise to your kind of provocation...*

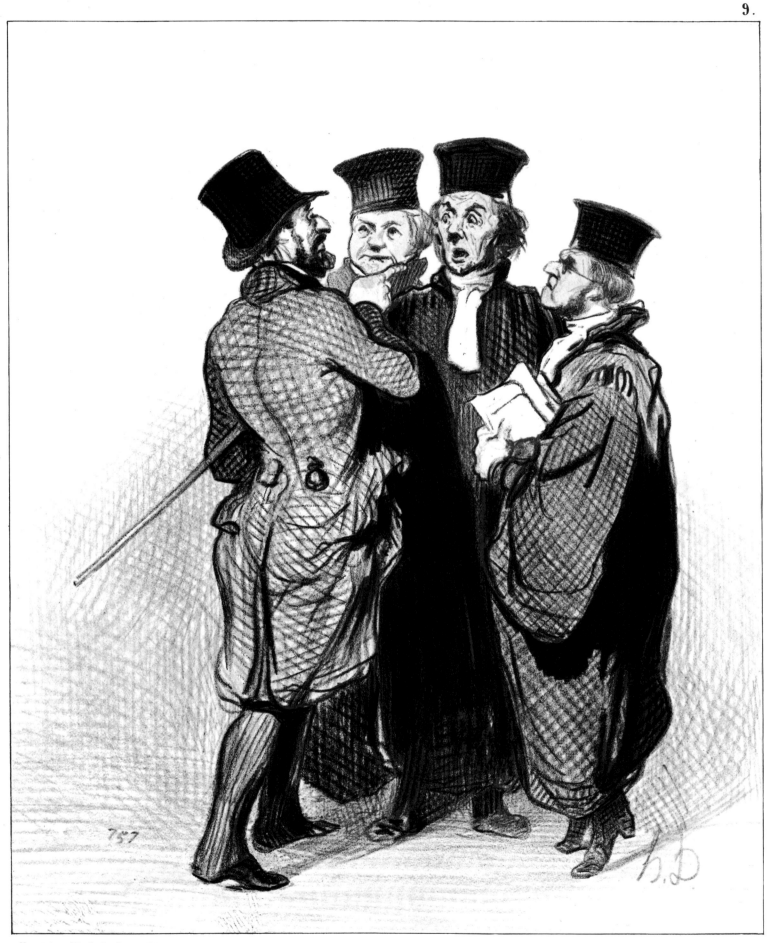

Chez Aubert Pl. de la Bourse, 29.

– Vous m'avez injurié dans votre plaidoirie, mais je saurai bien vous forcer à m'en rendre raison !...

– Monsieur apprenez que je ne vous crains pas !.. j'ai au plus haut dégré, le courage civil de ne jamais répondre à une provocation !...

No 10

— ... and, in addressing the defendant's alleged Concierge, informed her that he was under obligation
to comply with the said summons, in default of and failing which, he would be liable to all the constraints
of the law; and speaking as heretofore, served a copy of this present...
— What? Speaking as hear to four?... hear who?... to four what?...

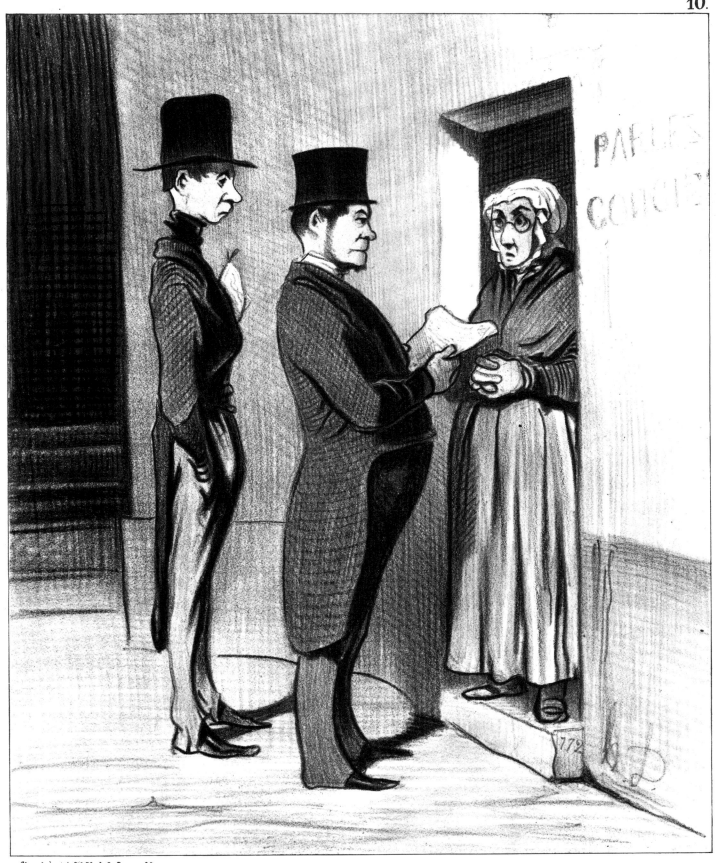

Chez Aubert & Cⁱᵉ Pl. de la Bourse, 29.

— et parlant à sa portière ainsi déclarée, lui ai signifié qu'il eut à obtempérer à la dite sommation, sinon et faute de ce faire, qu'il y sera contraint par toutes les voies de droit, et lui ai, parlant comme dessus, laissé copie du présent

— Comment! parlant comme dessus comme dessus qui, comme dessus quoi ?

No 11

— *Yes, they would plunder this orphan, whom I cannot describe as young since he is fifty-seven years old,*
but is no less an orphan for that... Yet I am not in the least anxious, for justice always keeps
a watchful eye open for such dastardly plots...

LES GENS DE JUSTICE

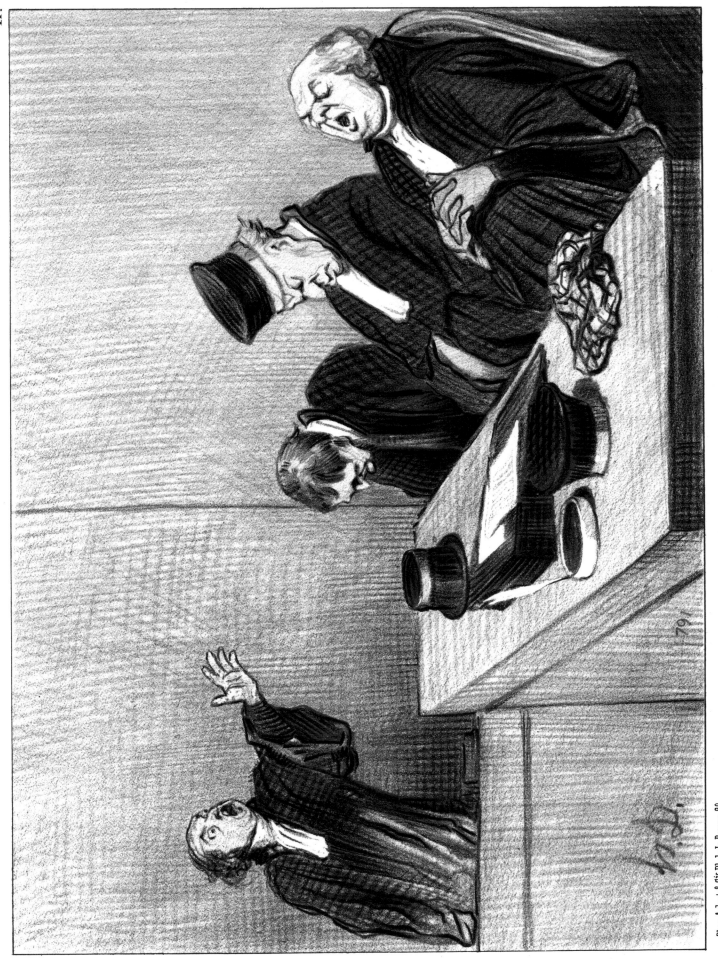

— Oui, on veut dépouiller cet orphelin, que je ne qualifie pas de jeune, puis qu'il a cinquante sept ans, mais il n'en est pas moins orphelin.... je me rassure toute fois, messieurs, car la justice a toujours les yeux ouverts sur toutes les coupables menées !......

— *That makes three defendants on whom I couldn't make the charges stick... I am in danger of losing my reputation...*

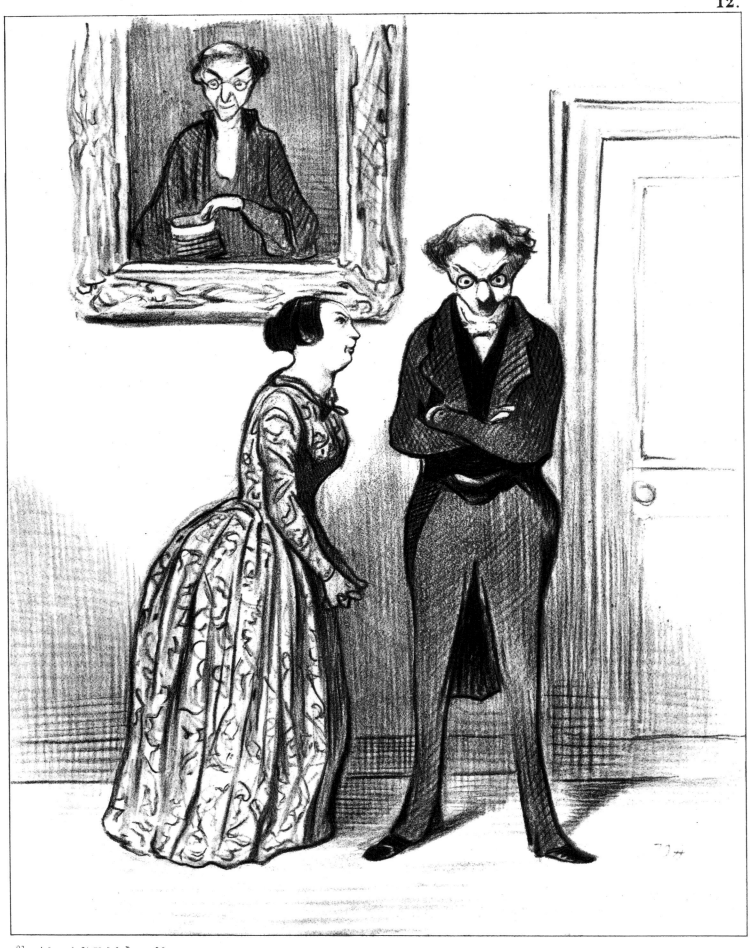

— Et dire que voilà trois de mes prévenus que je n'ai pas pu faire condamner !... je vais être perdu de réputation !....

Nº 13

— *My dear fellow, we were unfortunate, that's all... I was unable to prove your innocence this time...
but next time you are caught stealing I hope we shall be luckier...*

LES GENS DE JUSTICE

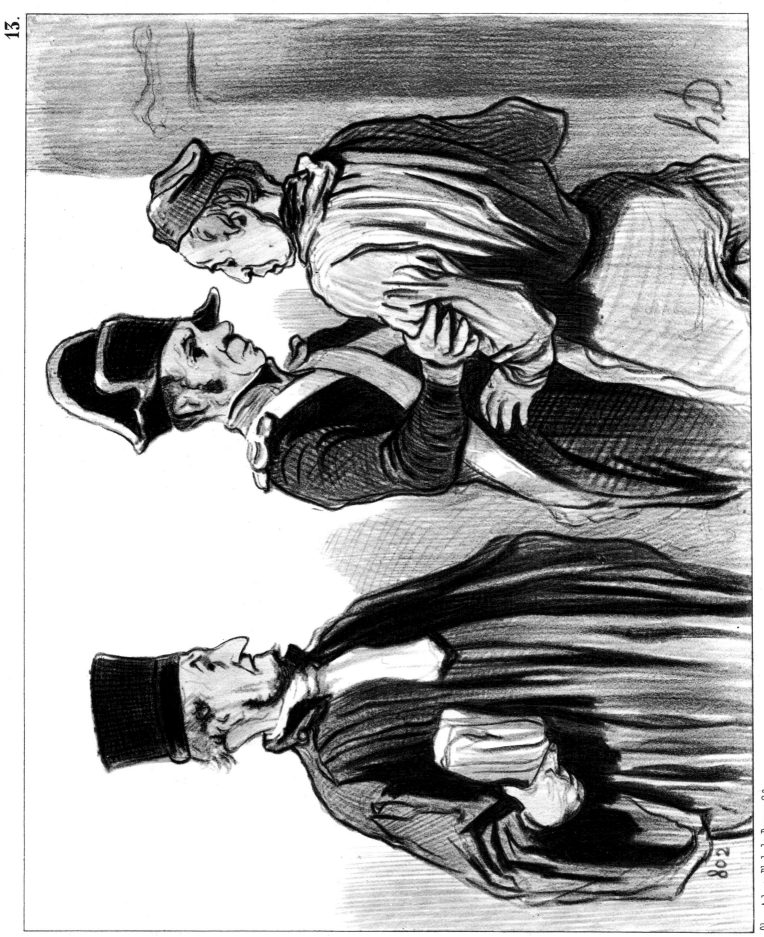

Chez Aubert Pl. de la Bourse, 29.

— Mon cher que voulez vous.... nous avons eu du malheur.... je n'ai pas pu prouver votre innocence, cette fois.... mais à
votre prochain vol j'espère être plus heureux !......

— *Well, my dear colleague, today you will be pleading against me a case identical to the one... I pleaded against you three weeks ago... ha ha ha... that's funny...*
— *Yes, and I shall fling back in your face the arguments you opposed to mine on that occasion... it's quite a joke, if necessary we shall be able to prompt each other... he he he*

LES GENS DE JUSTICE

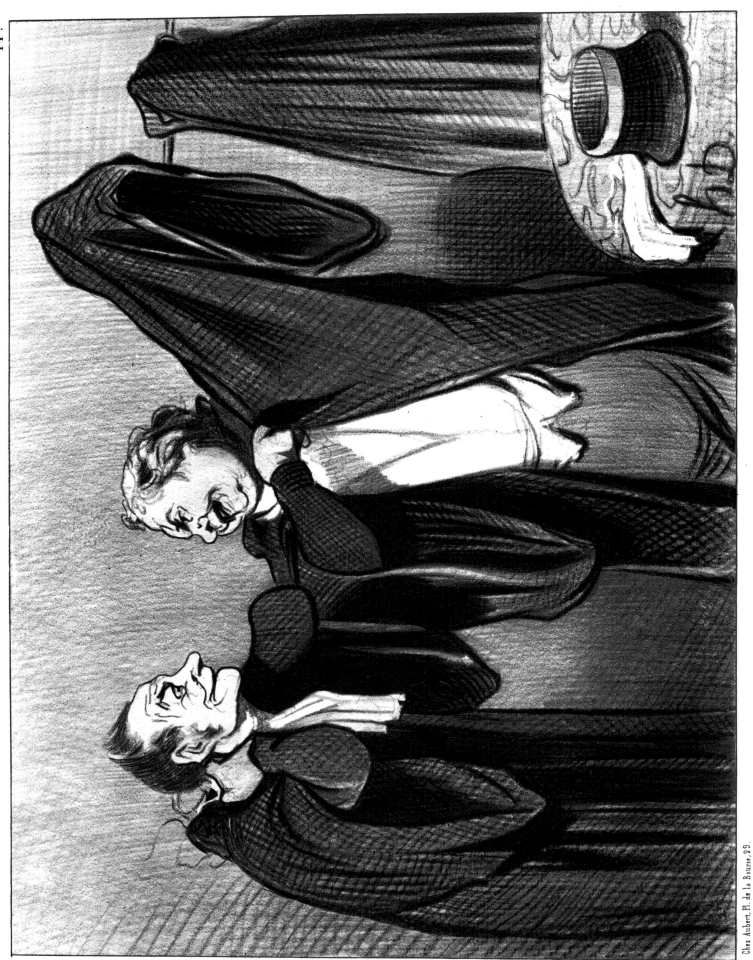

Dites donc, confrère, vous allez soutenir aujourd'hui contre moi absolument ce que je plaidais il y a trois semaines, dans une cause identique...hé hé hé!..c'est drôle!..

Et moi je vais vous redébiter ce que vous me ripostiez à cette époque...c'est très amusant, au besoin nous pourrons nous souffler mutuellement...hi hi hi!..

— *You were hungry... you were hungry... that's no excuse.... I am hungry practically every day yet I don't go out stealing!..*

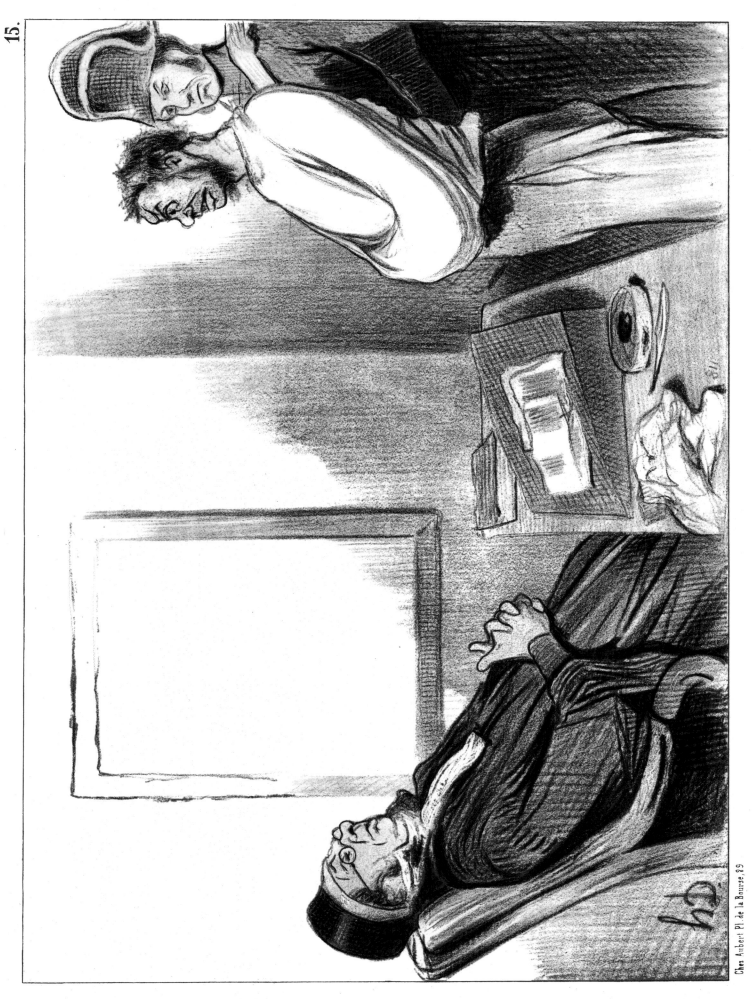

Vous aviez faim… vous aviez faim… ça n'est pas une raison… mais moi aussi presque tous les jours j'ai faim et
je ne vole pas pour cela !……

No 16

Defense Council compliments the Public Prosecutor on his brilliant presentation of the indictment;
the Public Prosecutor expresses his admiration for the Defense Council's eloquence;
the Presiding Judge congratulates both speakers; in short, everyone is more than satisfied... except the accused.

LES GENS DE JUSTICE

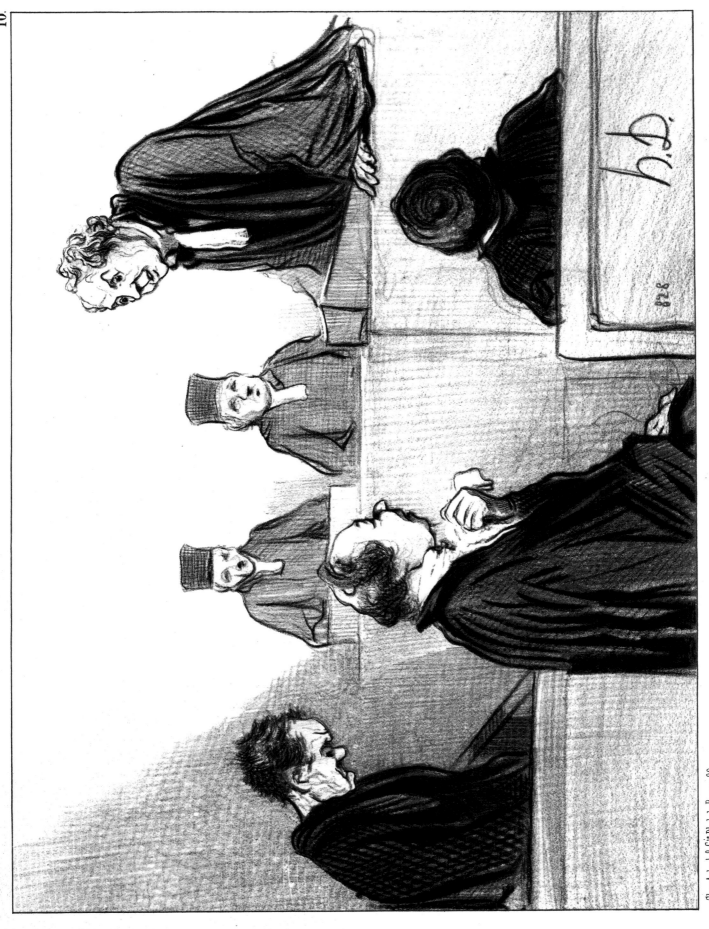

Mʳ l'avocat a rendu pleine justice au rare talent déployé par le ministère public dans son réquisitoire ; Mʳ le procureur général s'empresse de rendre un hommage mérité à l'admirable éloquence du défenseur, Mʳ le président applaudit aux deux orateurs ; bref tout le monde est excessivement satisfait, excepté l'accusé.

— *Come now, witness, it is most important that you give us exact details of how you spent the 12th of April last...*
— *But, your Honor, that was nine months ago...*
— *That makes no difference... tell us all the same...*

LES GENS DE JUSTICE

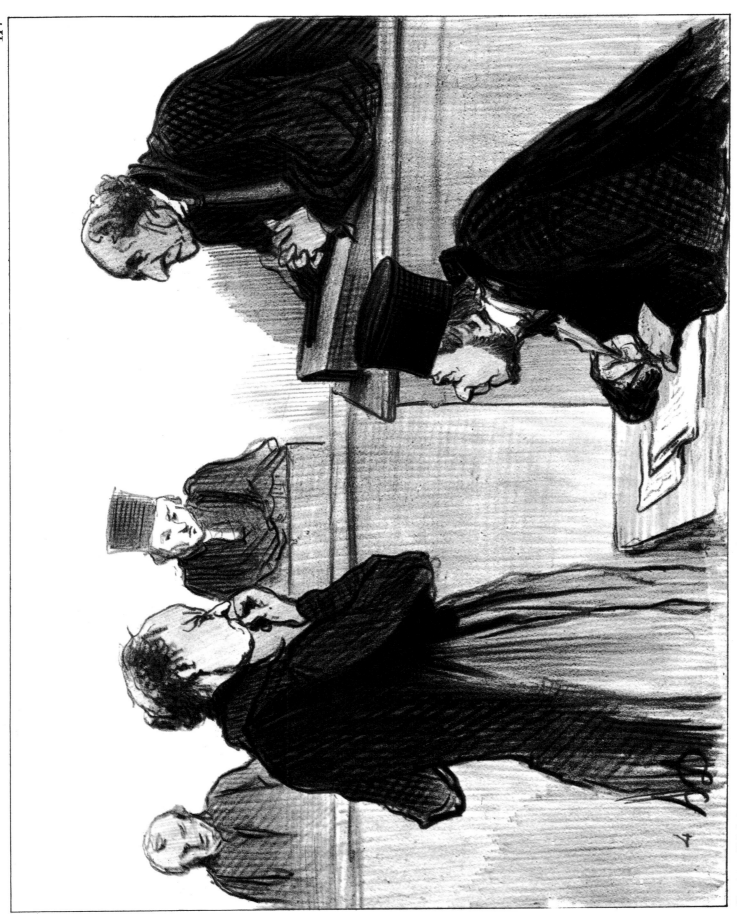

Chez Aubert Pl. de la Bourse 29.

— Voyons témoin il serait important de nous faire le détail éxact et complet de l'emploi de votre journée du 12 Avril dernier?..

— Mais m'sieu le président il y a neuf mois de cela

— Ça ne fait rien dites toujours ! . . .

N° 18

Lawyer Smug reading in a legal quarterly a eulogy of himself written by . . . himself . . .

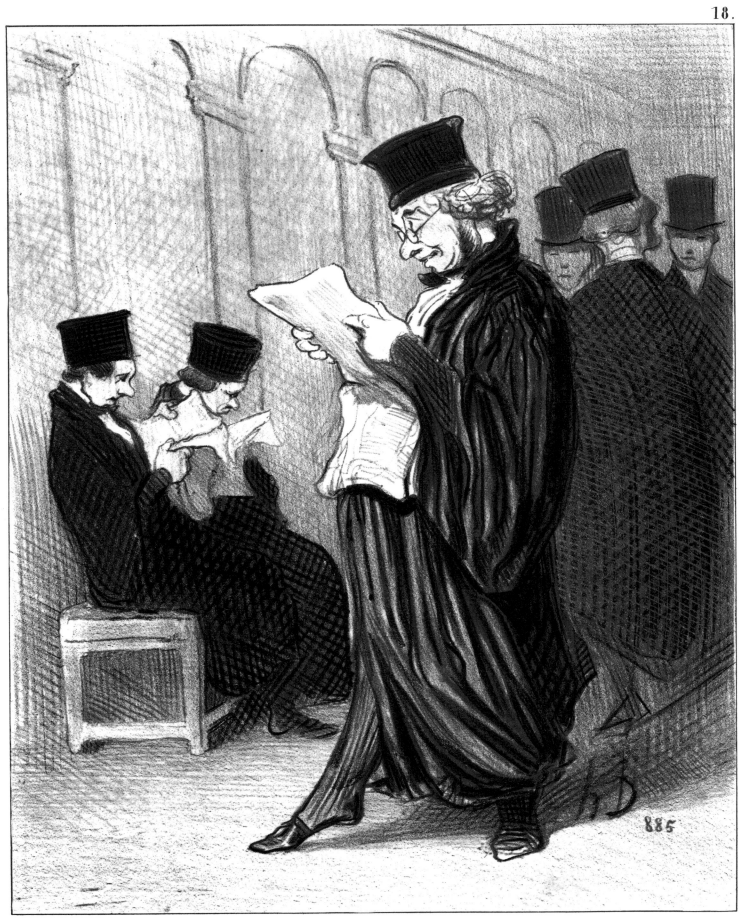

Chez Aubert, Pl. de la Bourse, 29.

Maitre Chapotard lisant dans un journal judiciaire l'éloge de lui même par lui même.

— *What worries me is that I am charged with twelve thefts...*
— *Twelve thefts, eh... so much the better... I shall plead an obsessive condition...*

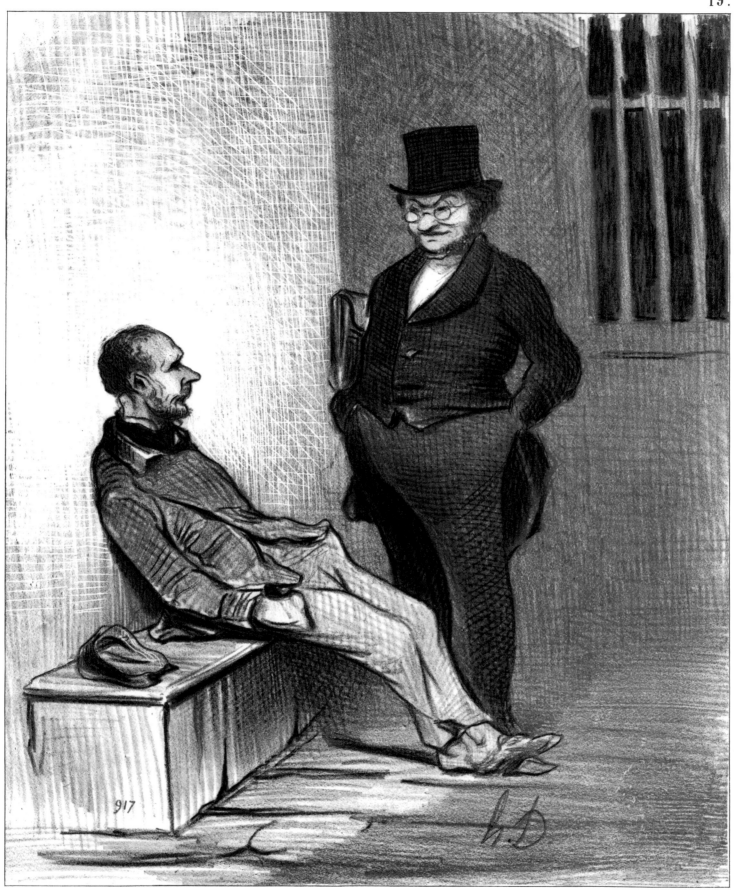

_ Ce qui m'chiffonne c'est que j'suis accusé de douze vols!..
_ Il y en a douze... tant mieux... je plaiderai la monomanie!..

— *My dear Sir, it is quite impossible for me to take on your case... You lack the most important piece of evidence... (aside) evidence that you can pay my fee !..*

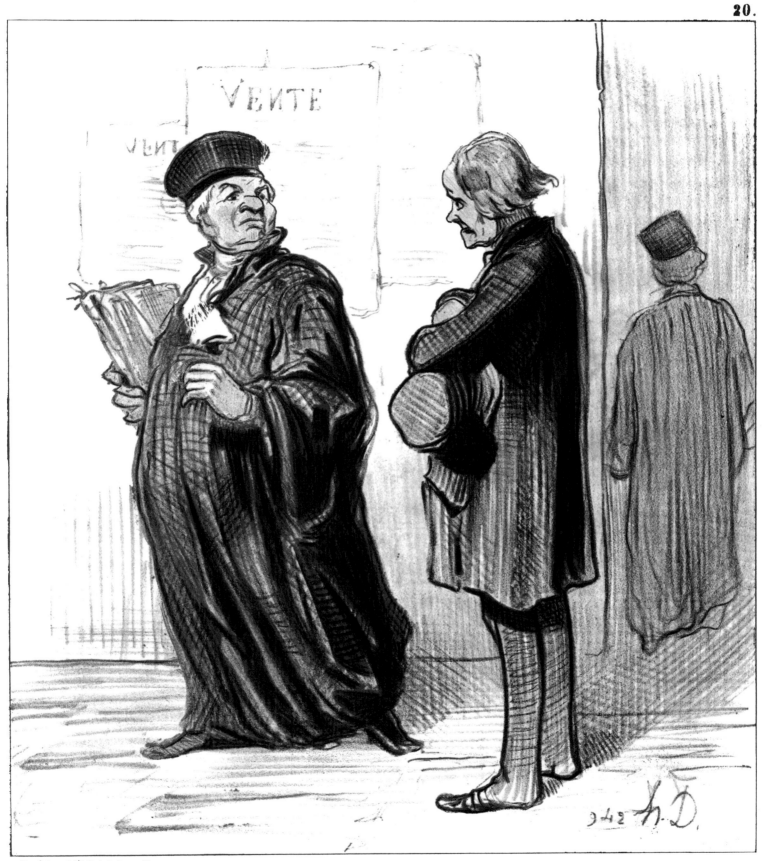

– Mon cher monsieur, il m'est absolument impossible de plaider votre affaire..... il vous
manque les pièces les plus importantes...... *(à part)* les pièces de cent sous !.........

No 21

— *The Public Prosecutor has just said some most unpleasant things about you.... try to cry or at least squeeze out a tear or two... that always makes a good impression...*

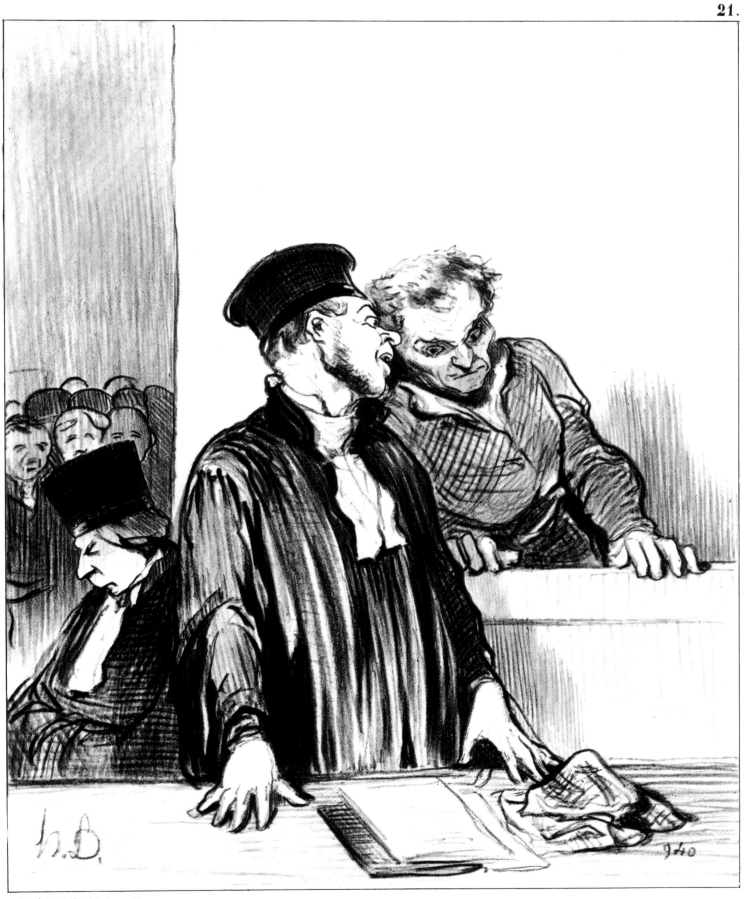

Chez Aubert & Cᵉ Pl. de la Bourse, 29.

– Voilà le ministère public qui vous dit des choses très désagréables tâchez donc de pleurer au moins d'un œil ça fait toujours bien !

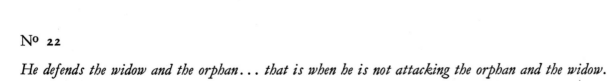

He defends the widow and the orphan . . . that is when he is not attacking the orphan and the widow.

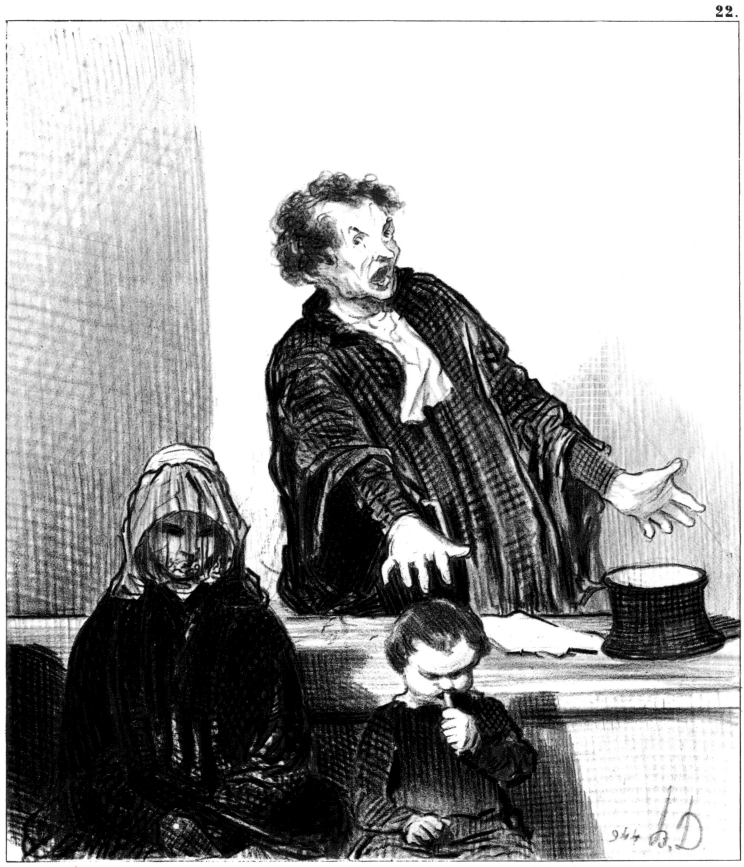

Il défend l'orphelin et la veuve, à moins pourtant qu'il n'attaque la veuve et l'orphelin.

At the Café d'Aguesseau (a restaurant near the law courts)
While awaiting the hearing our Demosthenes lunches at the expense of his client; roast beef and potatoes
can be a great encouragement to eloquence.

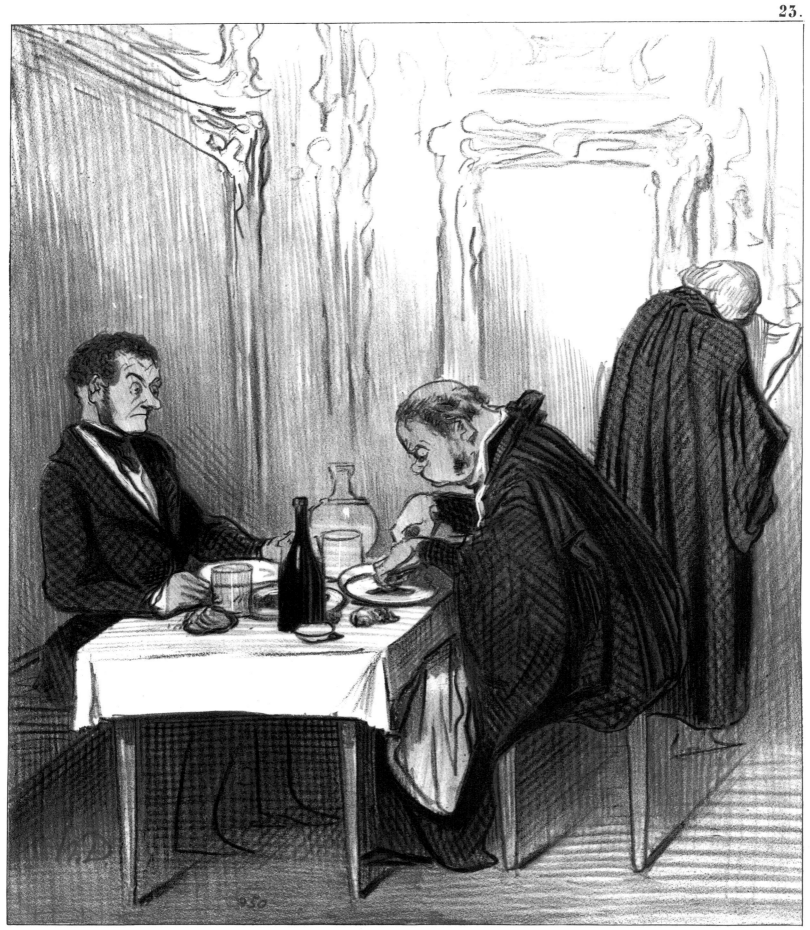

AU CAFÉ D'AGUESSEAU.

En attendant l'audience, Démosthène déjeune aux frais du client, le bifteck aux pommes pousse
à l'éloquence.

— *What a pity that lovely little lady didn't confide her case to me... in my pleading I would have made her husband out to be a real scoundrel...*

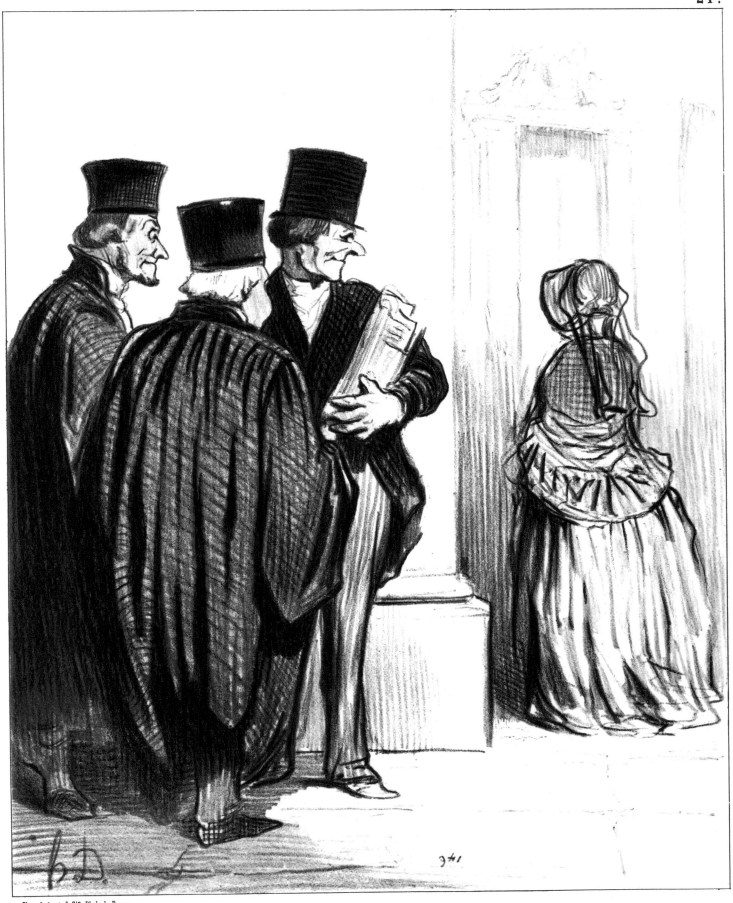

– Quel dommage que cette charmante petite femme ne m'ait pas chargé de défendre sa cause....... comme je plaiderais que son mari est un gredin!.....

No 25

The judge of the reconciliation court has given his judgement, the parties are deemed to be reconciled.

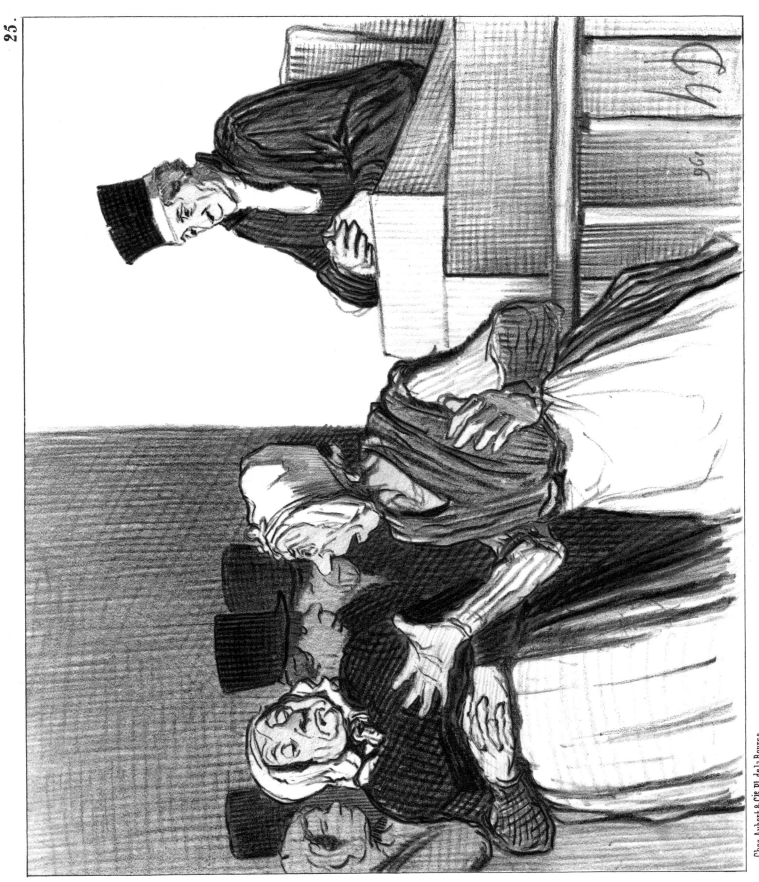

LES GENS DE JUSTICE

Mͬ le juge de paix a rendu sa décision, les parties sont censées conciliées.

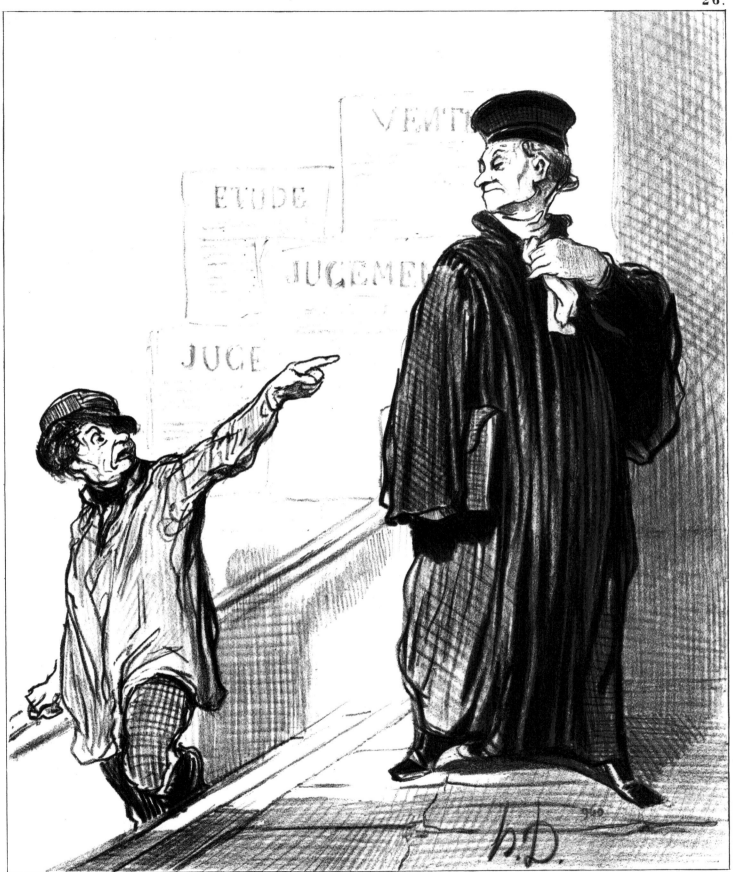

Un plaideur peu satisfait.

No 27

A defense lawyer discussing business matters at his usual office.

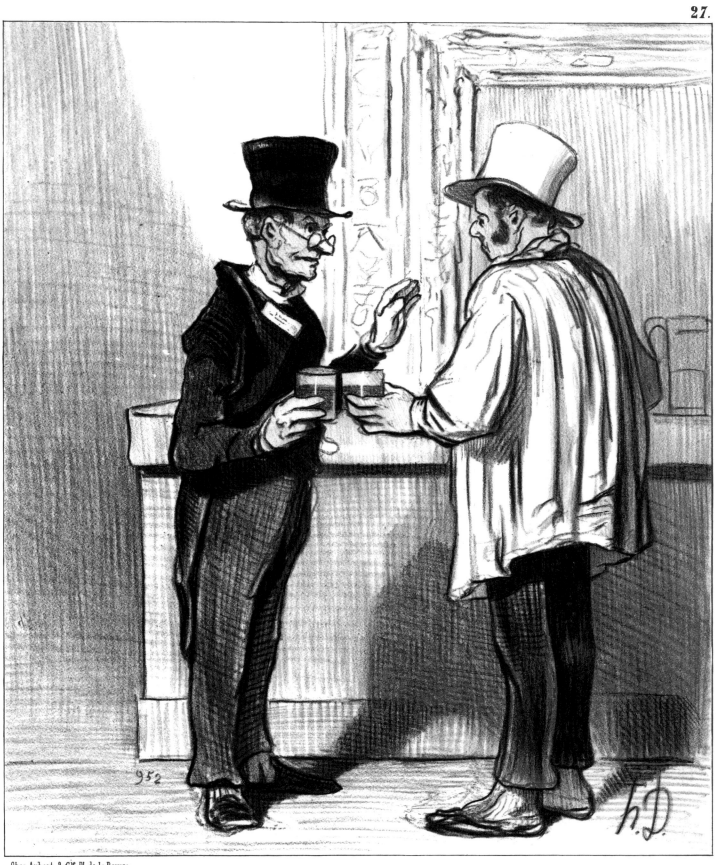

Un défenseur en Justice de Paix. causant affaires dans son cabinet habituel.

No 28

— *So even if I admit, between ourselves, that I stole old father Jerome's watch, you won't leave me in the lurch?...*
— *My dear pickpocket, you certainly don't understand my position... If there were no offenders there would be no lawyers...*
now that I know for certain you are guilty I shall establish your alibi...

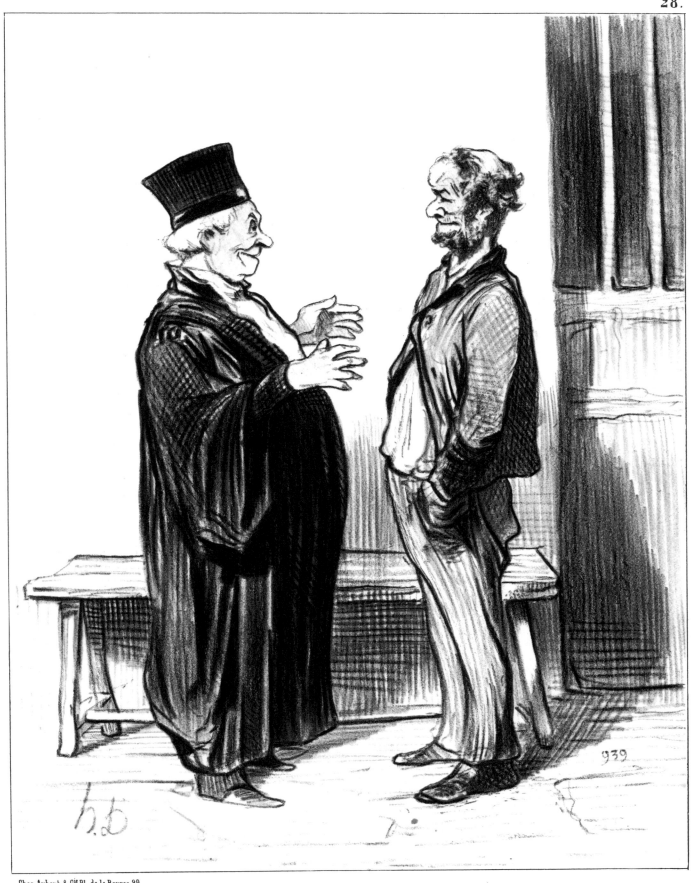

Chez Aubert & Cie Pl. de la Bourse, 29.

— Ainsi donc, quoique j'vous avoue, entre nous, qu'c'est moi qu'a volé la toquante au père Jérôme, vous n'm'abandonnez pas pour ça!....

— Eh! mon cher voleur.... vous connaissez bien mal mon cœur....s'il n'y avait plus de filous il n'y aurait plus d'avocats.....maintenant que je suis bien certain que c'est vous qui avez fait le coup....je plaiderai l'**alibi**!...

— *Take him to Court... that would be a good trick to play on your neighbour... he would have to eat into his savings to the extent of at least three hundred francs...*
— *Yes, but I would have to eat into my savings too and I have no appetite for that...*

LES GENS DE JUSTICE

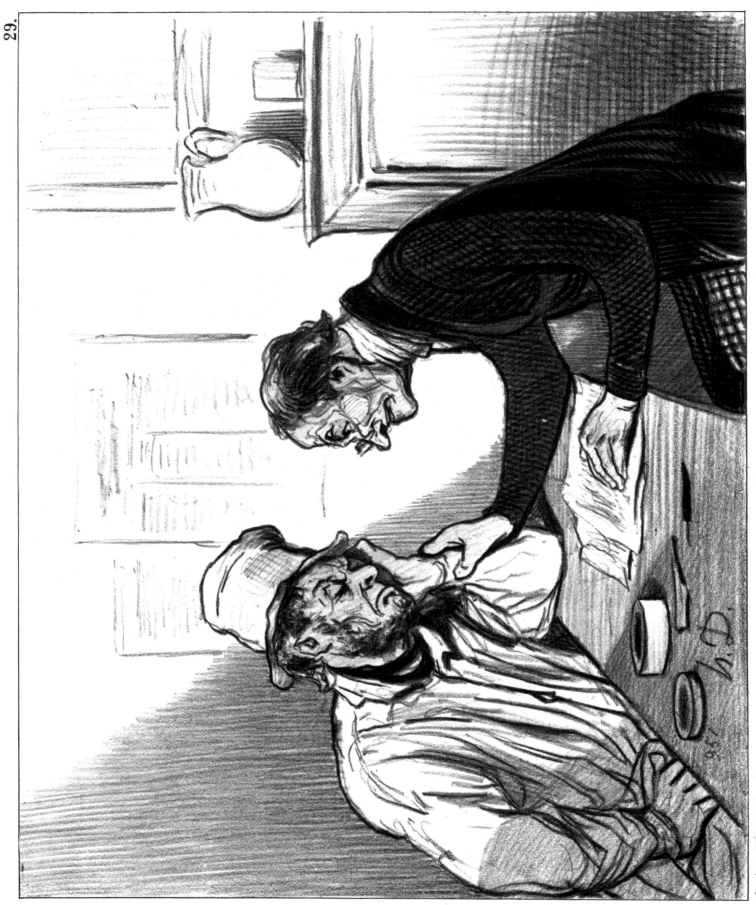

Chez Aubert & Cie Pl. de la Bourse, 29

— Plaidez, plaidez..... ça sera un bon tour à jouer à votre voisin....vous lui ferez manger plus de cent écus!.....

— Oui, mais c'est qu'moi...j'en mangerais itou des miens.....des écus.....et j'ai pas d'appétit pour ça!

No 30

The lawyer who doesn't feel well, the last resort when his case is beginning to look sick.

LES GENS DE JUSTICE

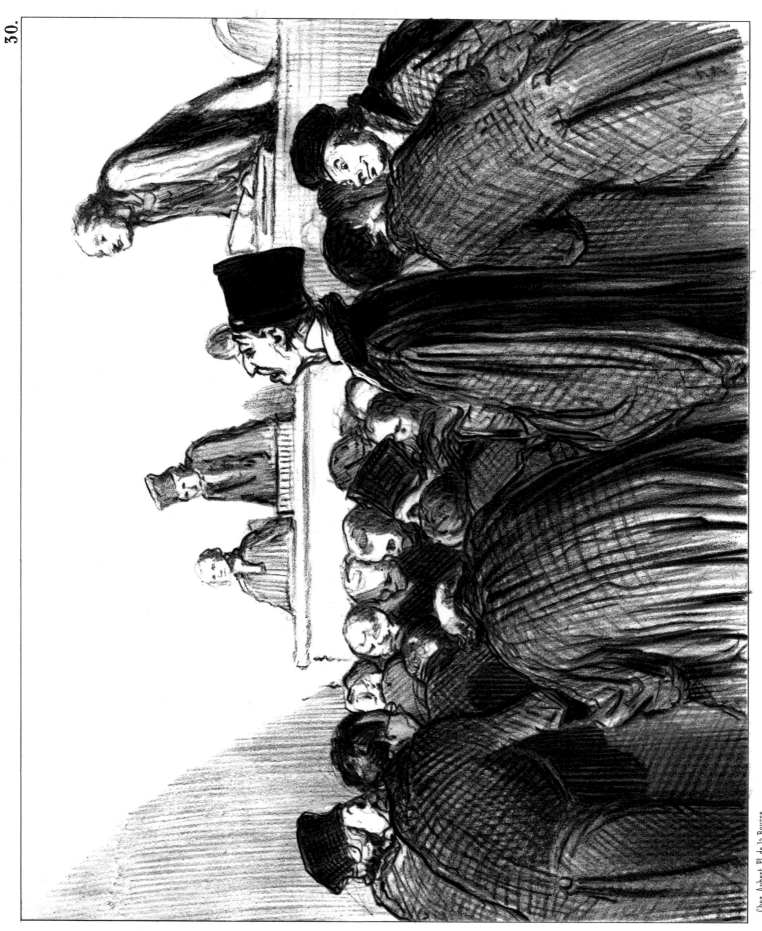

Chez Aubert Pl de la Bourse

L'avocat qui se trouve mal, — dernière ressource quand la cause est bien malade.

— *Should be a good performance today, Mr Galuchet...*
— *I should say so... a murder with rape thrown in...*

LES GENS DE JUSTICE

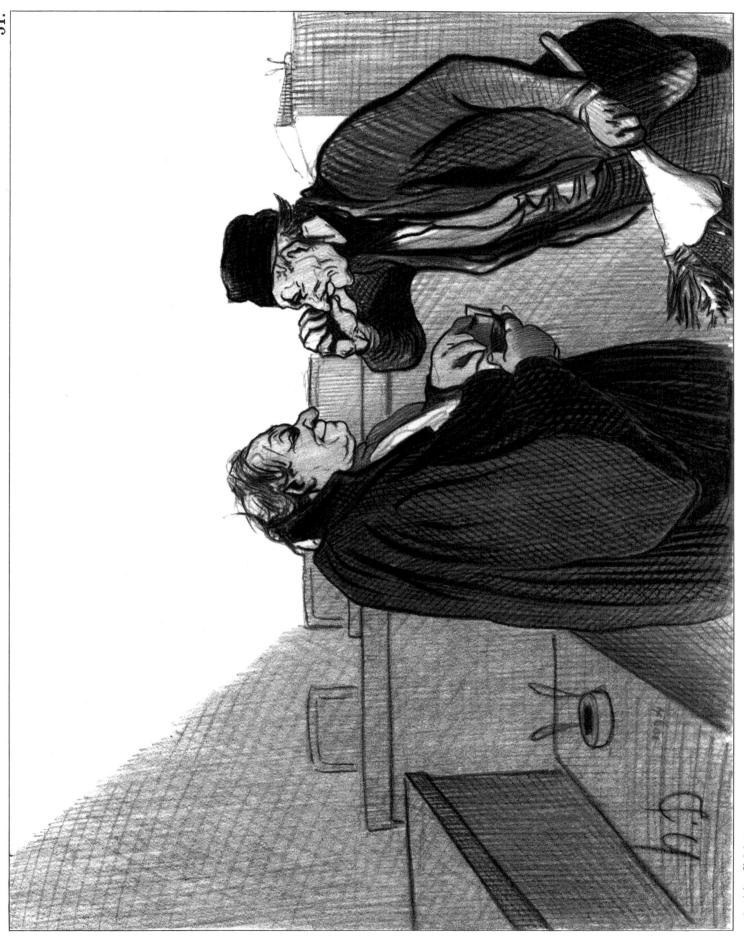

— Nous avons grande représentation aujourd'hui, M'sieu Galuchet !.....
— Parbleu j'crois bien un assassinat orné de viol !......

No 32

— *Never mind... let him say a few unpleasant things about you... in a minute or two I am going to abuse his entire family...*

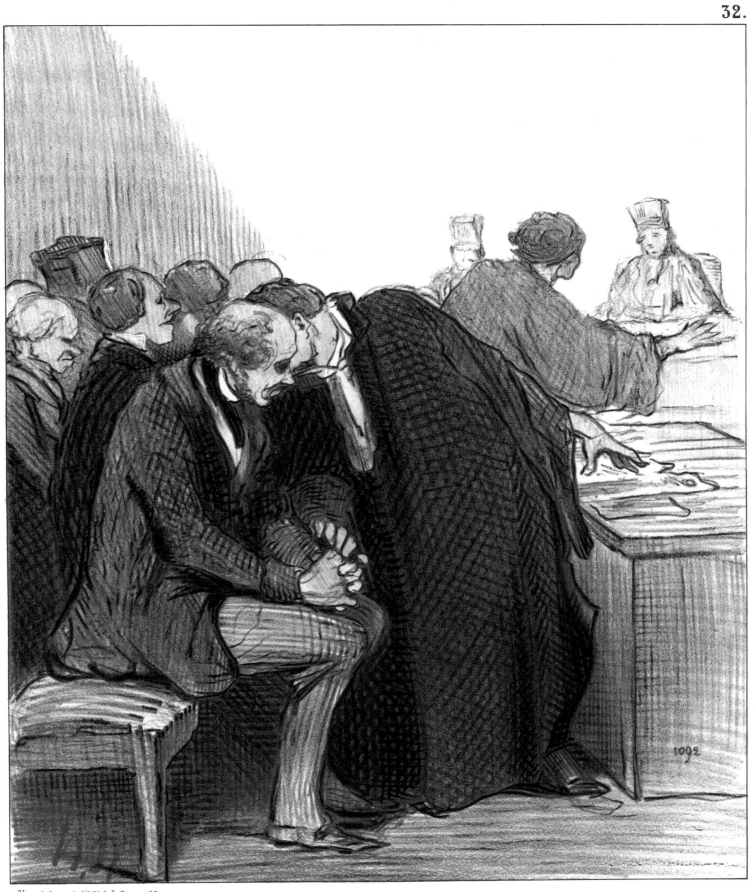

– Laissez dire un peu de mal de vous laissez dire tout à l'heure, moi, je vais injurier toute la famille de votre adversaire ! . . .

No 33

An oration worthy of Demosthenes.

LES GENS DE JUSTICE

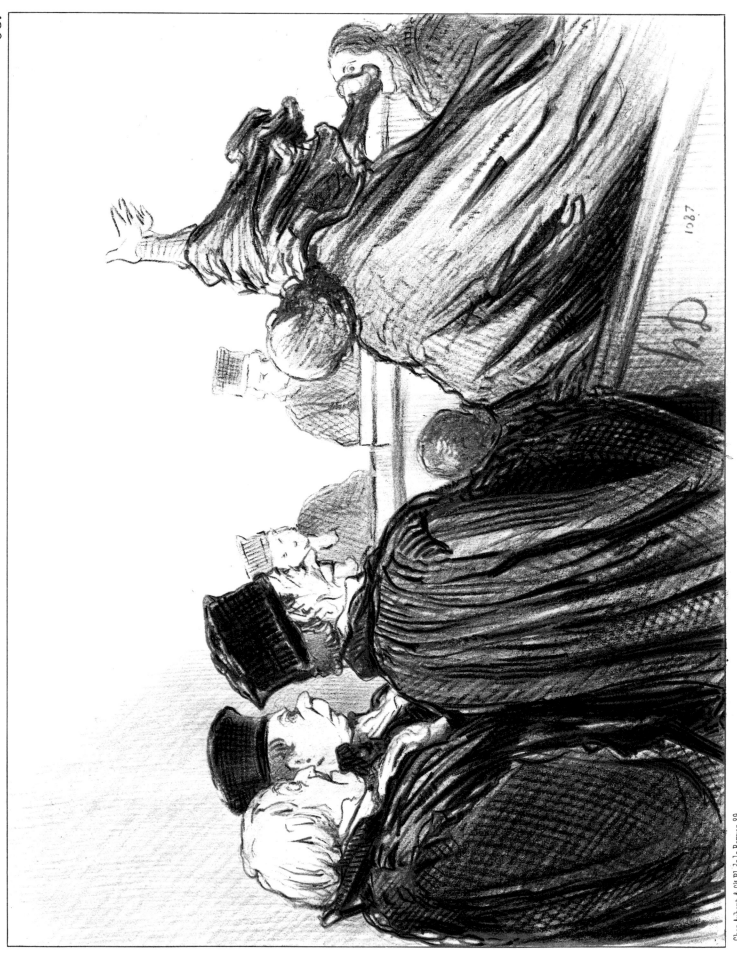

Chez Aubert & C.ie Pl.de la Bourse, 29.

Une péroraison à la Démosthène.

N⁰ 34

— Case lost again in the Royal Court (Appeal Court)... and he is as worried as if there wasn't still the Upper Appeal Court to go to...

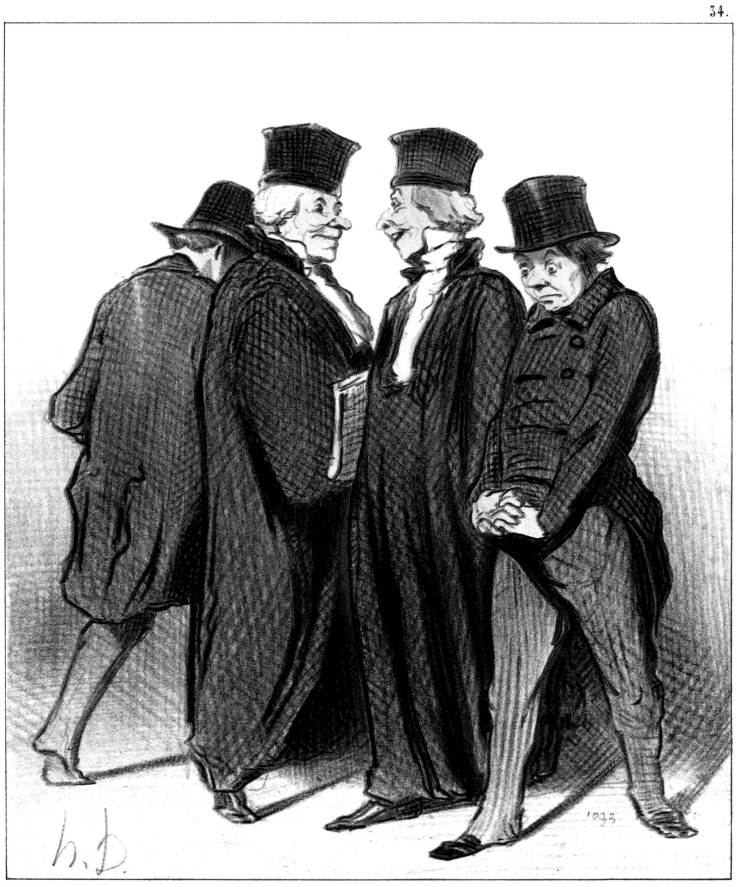

_ Encore perdu en Cour Royale ... et il se lamente comme s'il ne lui restait
pas encore la Cour de Cassation! ...

No 35

— *It's true you lost your case . . . but at least you had the pleasure of hearing me make my plea.*

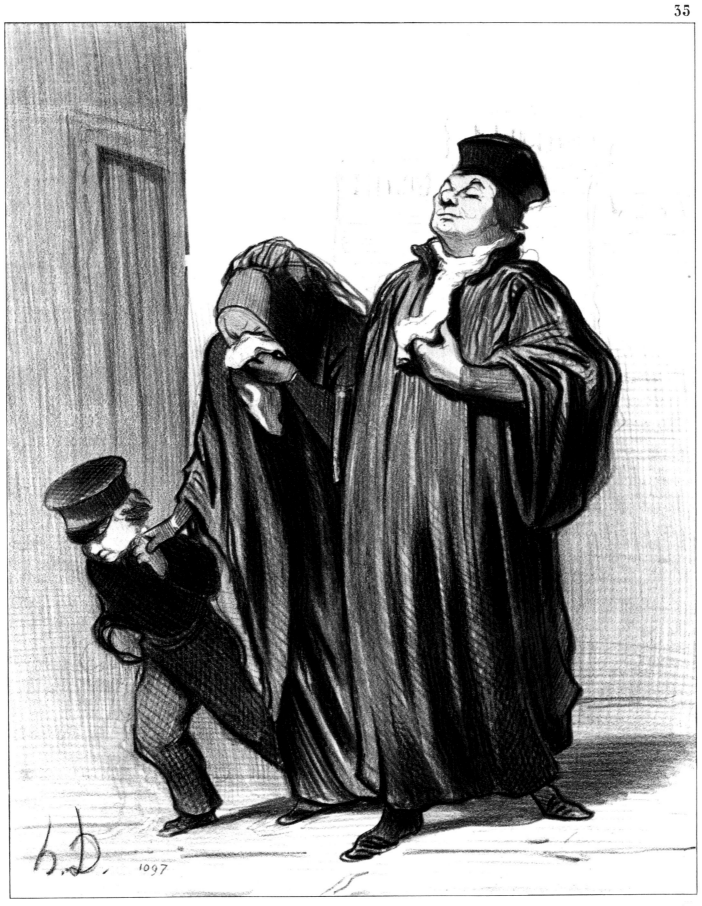

— Vous avez perdu votre procès c'est vrai mais vous avez du éprouver bien du plaisir à m'entendre plaider.

N⁰ 36

Main staircase of the Palace of Justice
Face on view

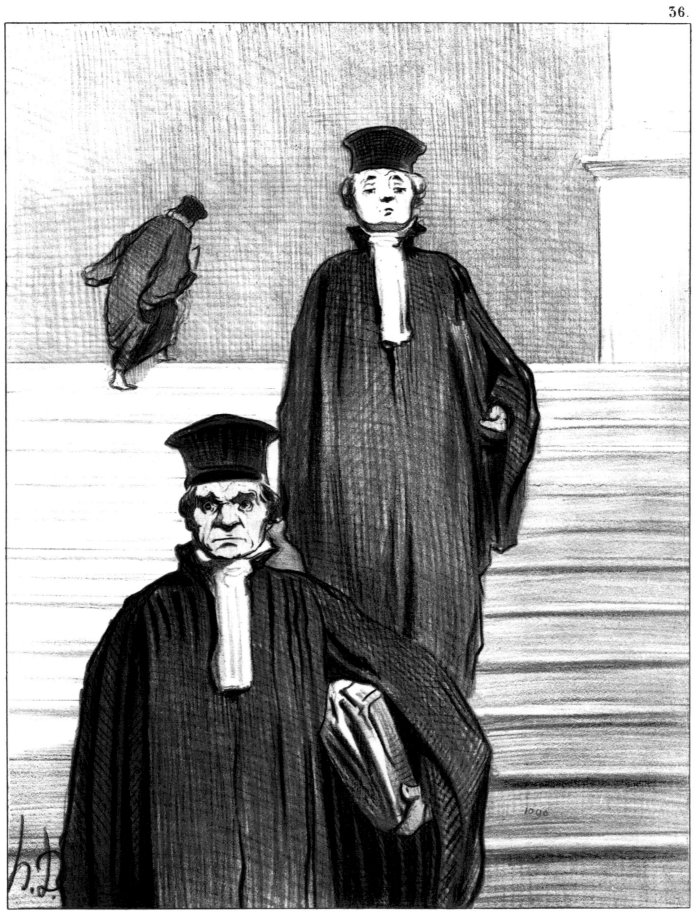

Grand escalier du Palais de justice.
Vue de faces.

Chez Aubert, Pl. de la Bourse.

N° 37

— *It seems my customer is a real villain... so much the better... all the more credit to me if I manage to get him off...*

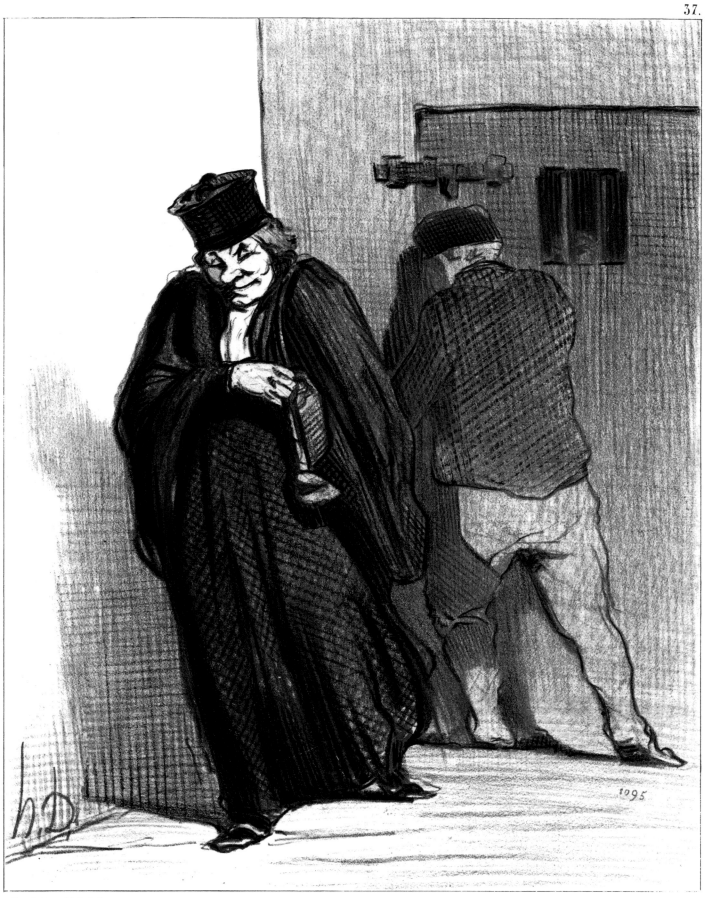

— Il parait décidément que mon gaillard est un grand scélérat tant mieux
si je parviens à le faire acquitter, quel honneur pour moi !

No 38

When crime doesn't pay

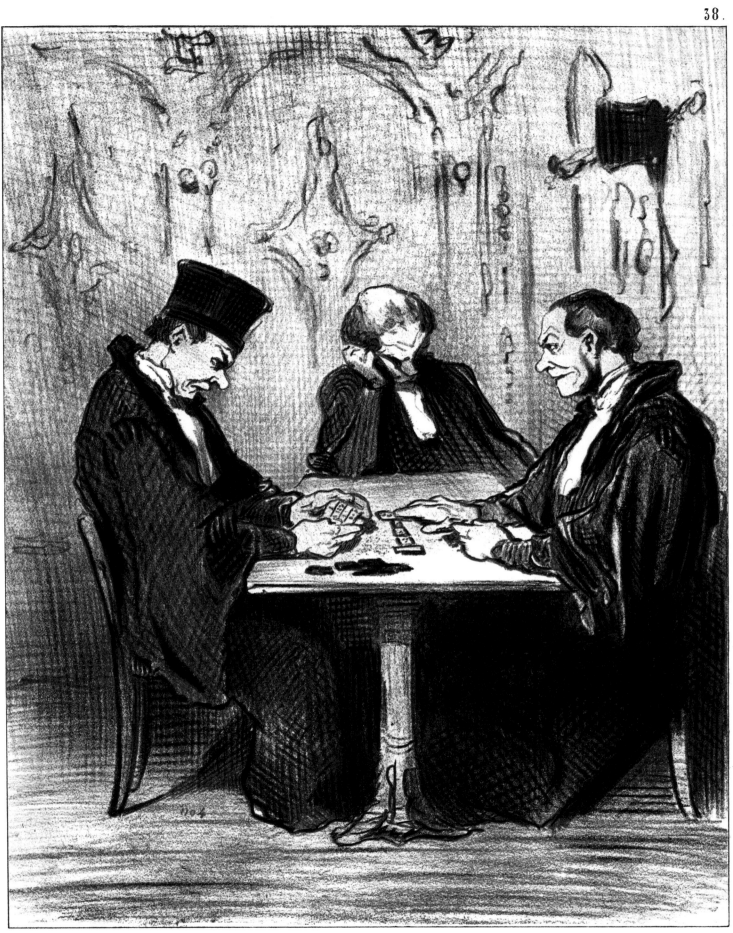

Chez Aubert, Pl. de la Bourse.

Quand le crime ne donne pas.

— *You are very pretty... we shall easily prove that it was all your husband's fault...*

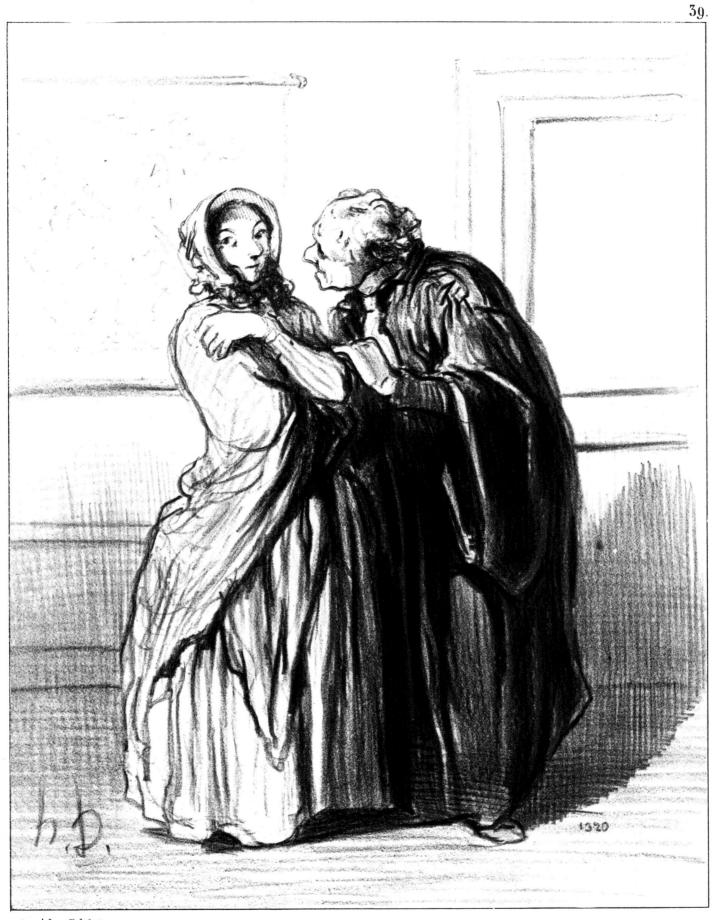

— Vous êtes jolie nous prouverons facilement que votre mari a eu tous les torts !

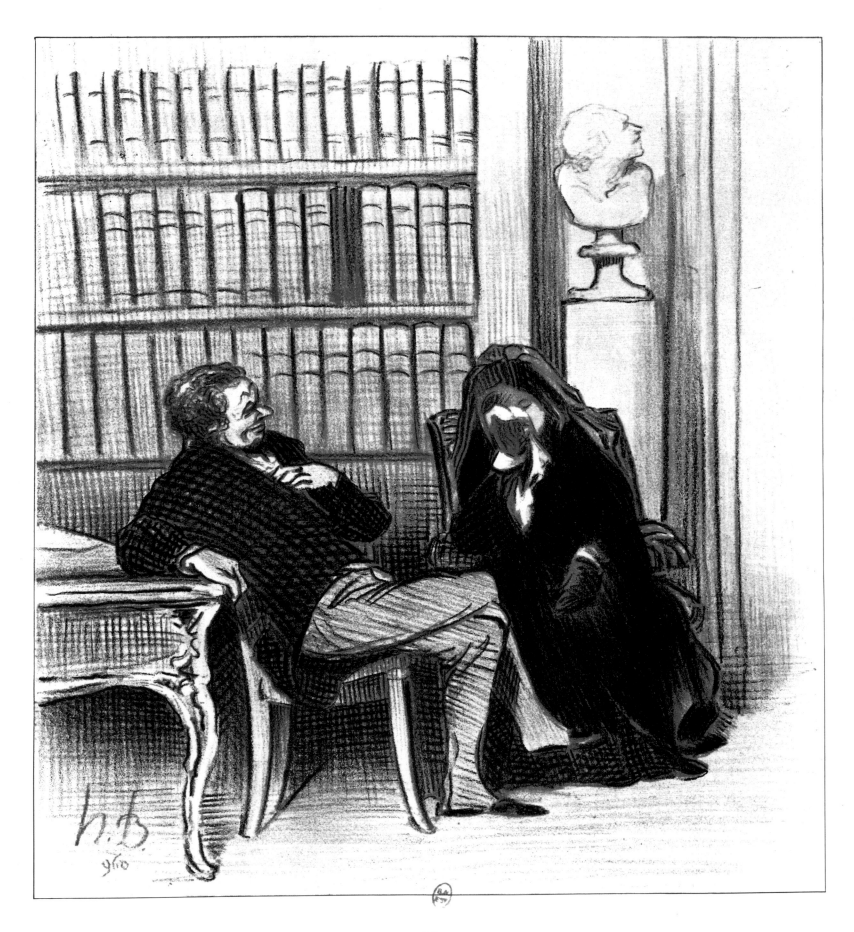

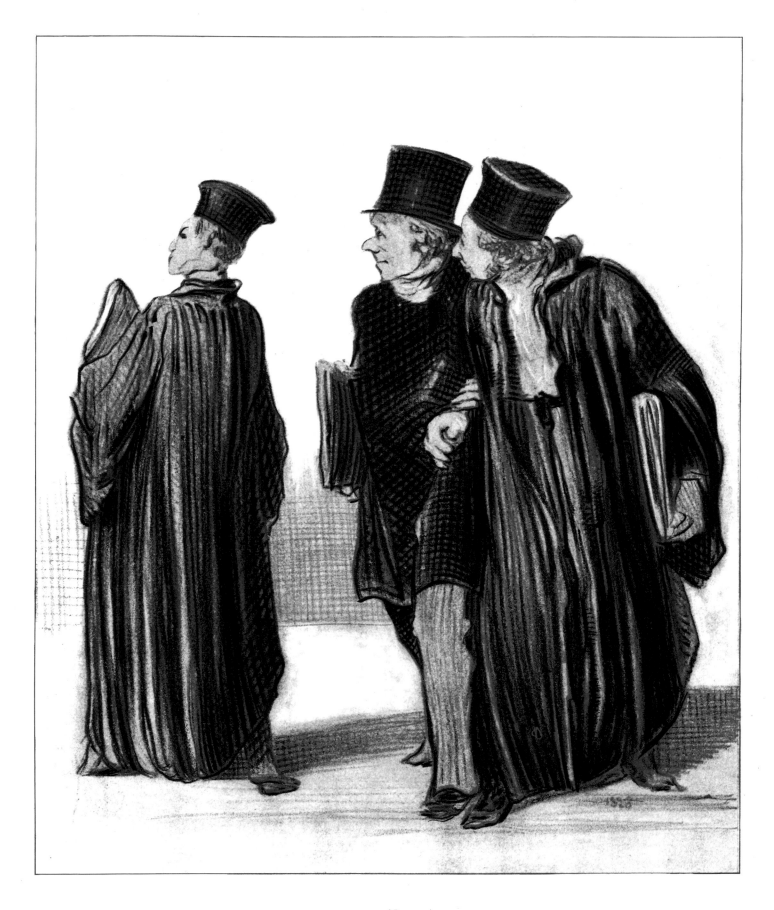

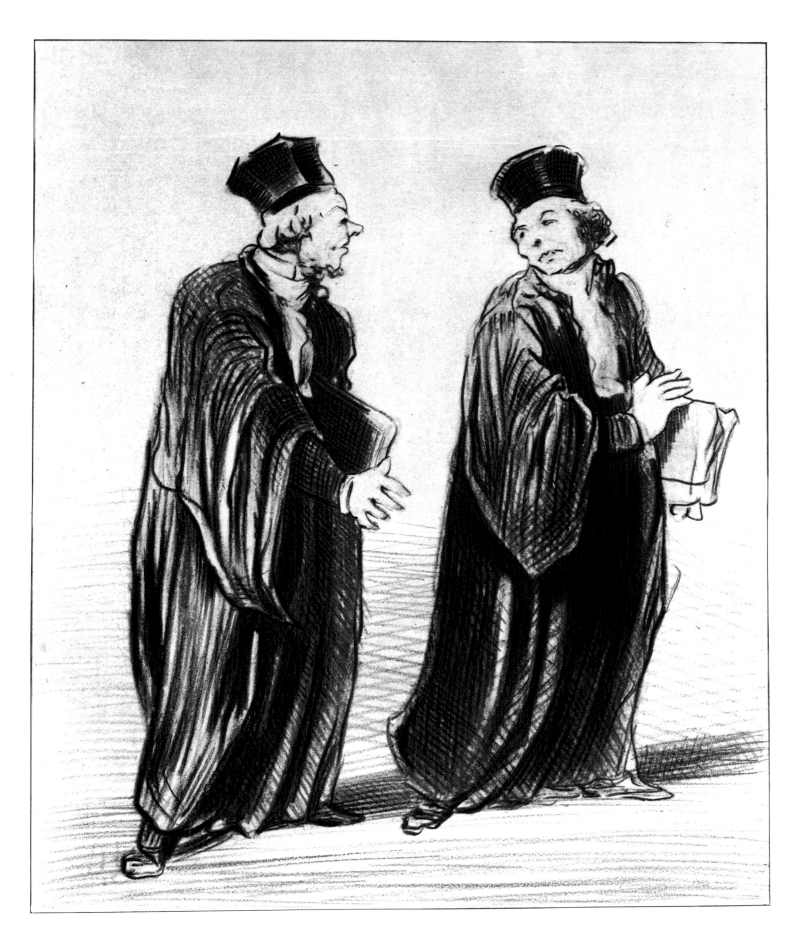

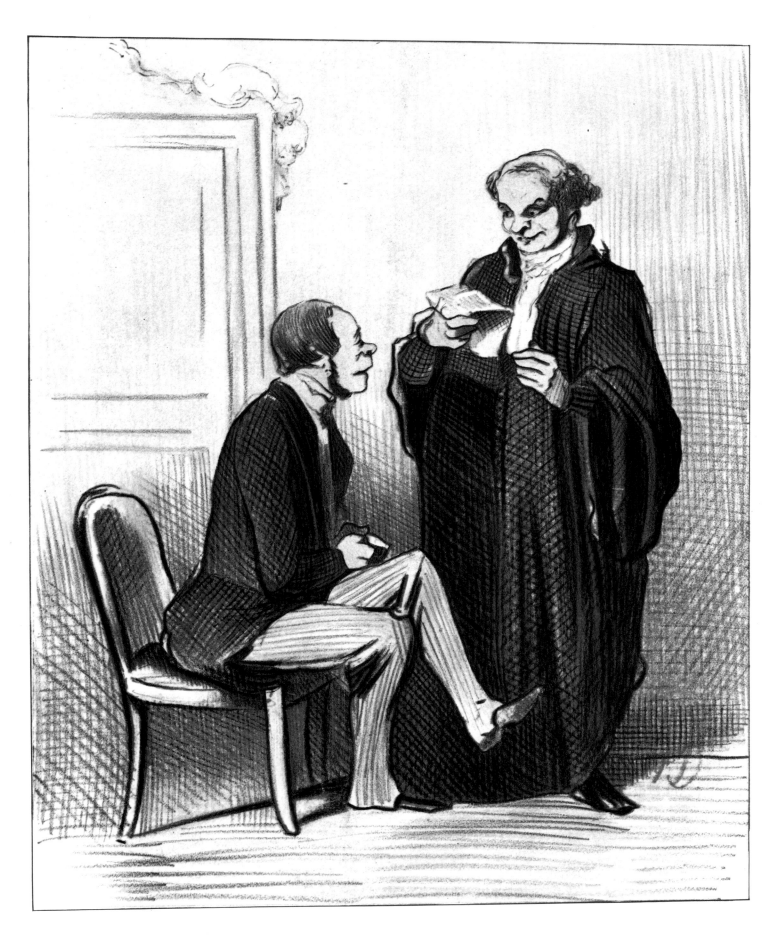

Lawyer—The case is coming along nicely; ve're making rapid strides.
Client—That's what you told me four years ago; if we keep striding on much longer I shall be barefoot before we get there...

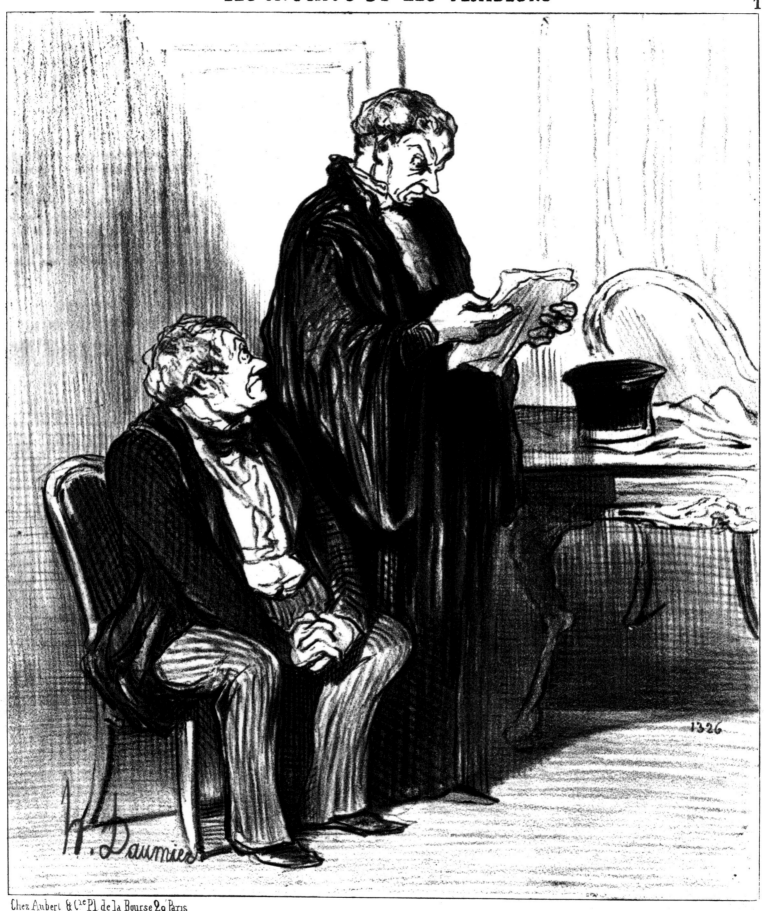

Chez Aubert & Cie Pl de la Bourse, 29 Paris

L'avocat. — L'affaire marche, l'affaire marche!

Le plaideur. — Vous me dites cela depuis quatre ans; si elle marche encore longtemps comme ça, je finirai par n'avoir plus de bottes pour la suivre!..

— *Everyone has got clients except me. In the end I shall have to commit some misdemeanour myself so that I can have the satisfaction of conducting my own defense.*

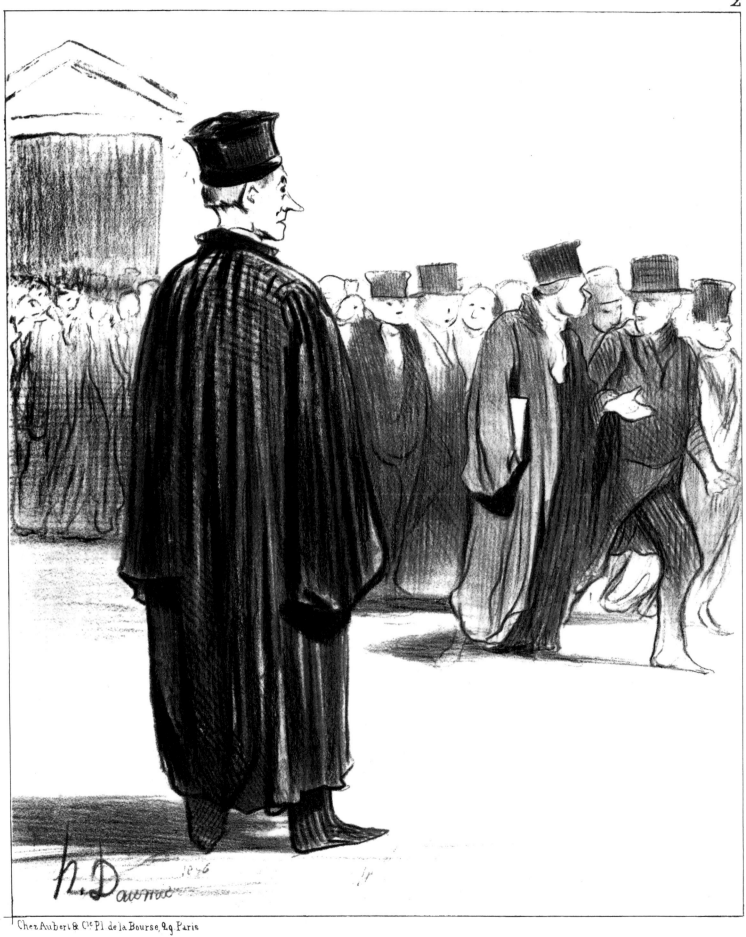

— Ils ont tous des cliens... moi seul n'en ai pas! il faudra que je finisse par commettre quelque forfait pour avoir enfin la satisfaction de me confier ma défense!

No 3

— *At last we have managed to obtain a partition of the wife's and the husband's property.*
— *Just in time, too, the case has ruined both of them.*

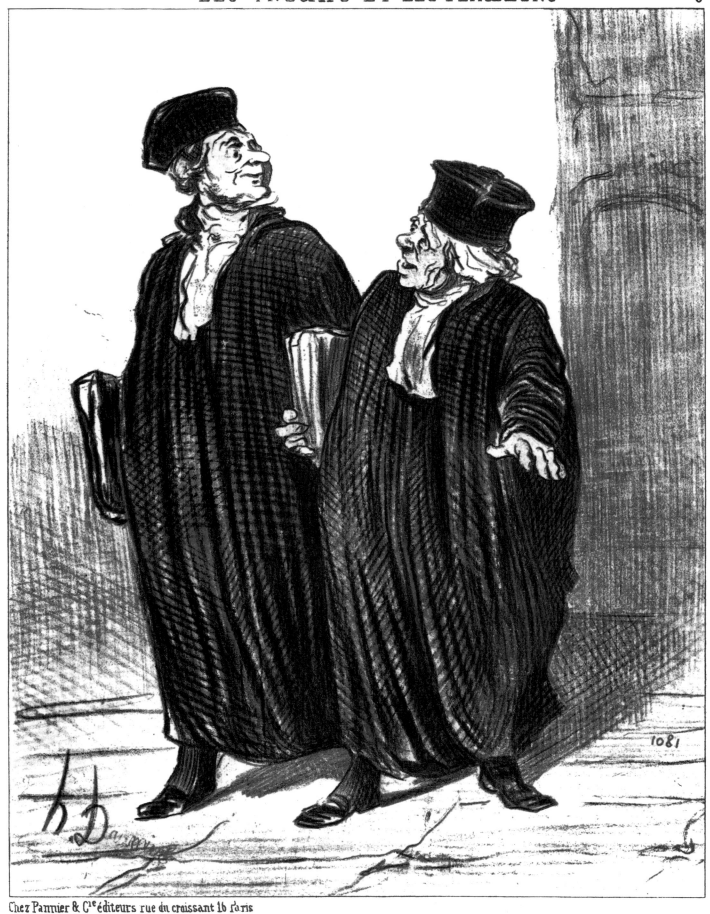

Chez Pannier & Cⁱᵉ éditeurs rue du croissant 16 Paris

_Enfin! nous avons obtenu la séparation de biens des deux époux.
_Il est bien temps, le procès les a ruinés tous les deux!

— *Don't forget to make a reply to my plea, and I shall reply to your reply... that will mean two more speeches for our clients to pay for...*

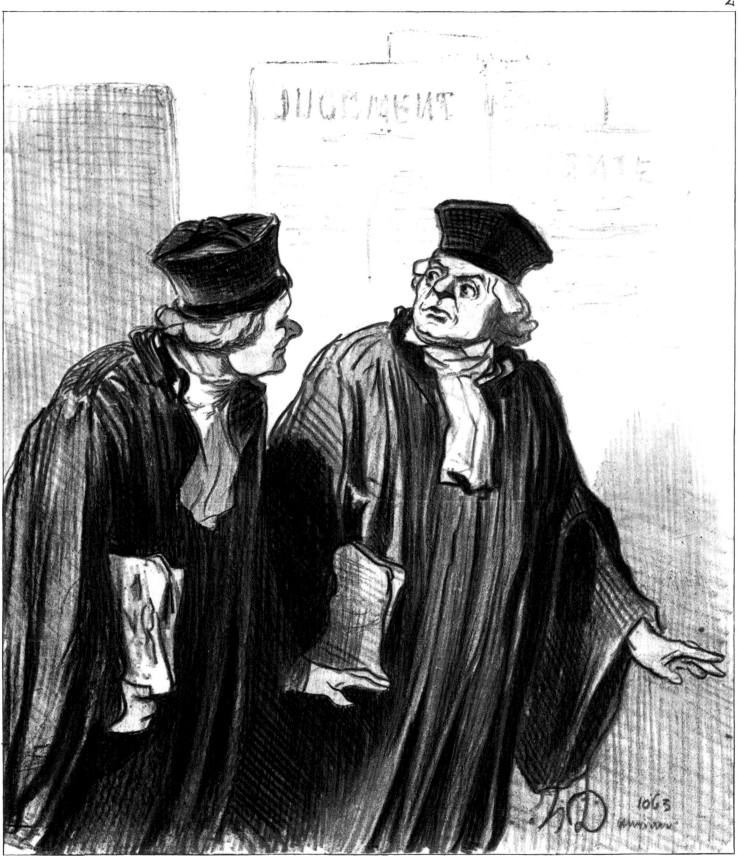

Chez Panmier & C.ⁱᵉ rue du croissant, 16 .Paris.

_ Ne manquez pas de me répliquer, moi je vous rerépliquerai...ça nous fera toujours deux plaidoiries de plus à faire payer à nos cliens !..

The Publication of the Plates

*T*HE *series entitled* Lawyers and Justice *appeared in* Le Charivari *at irregular intervals between March 21, 1845 and October 31, 1848, being interspersed by prints by Cham, Charles Vernier, Traviès as well as by other prints by Daumier.*

Charles Philipon, the manager of the newspaper, published the first three plates in consecutive issues of the paper at the end of March 1845 and he followed these with five in April and one in May; thereafter they appeared at longer intervals, only a few lithographs in July, August and October. This sequence was continued in January 1846, followed by two in March and one in June, a few others being published between August and November. After several months' interruption four more appeared between August and September 1847, while the series was concluded by the plates dating from January, February, April and October 1848.

At this point, Philipon called a halt to the publication, both because he wished Daumier to turn to other topics, and because he feared he might begin to repeat himself. Nevertheless, he still had a number of plates in his possession, which, excellent as they were, he refrained from publishing, or else published later under different titles, as follows:

1. The plate, wrongly numbered 39 by Delteil and entitled: 'You are, very pretty . . . We shall easily prove that it was all your husband's fault.' The only known print was made separately, as is also the case with No. 26 'A dissatisfied plaintiff', which had likewise been withheld from Le Charivari *in 1846. Unlike No. 26 it is unnumbered and certainly never attained publication.*

2. Four unnumbered plates, all without captions and all exceedingly rare: The Widow, *now in the Cabinet des Estampes,* The Two Lawyers *belonging to Monsieur Henri Thomas,* The Beginner *and* The Consultation, *both in the collection of Maître Maurice Loncle. (Delteil seems to have been unaware of the existence of either* The Widow *or* The Consultation.)*

3. *The four plates which appeared as late as 1851 under the new title* Lawyers and Litigants, *and which complements and continues the earlier series of* Lawyers and Justice.

It is worth discussing whether Daumier produced all these plates at once or whether they were done gradually, in accordance with the newspaper's requirements. It has in fact been established that he did not work on a single series at a time, but that he alternated his sketches dealing with the law with other series, such as Les Bons Bourgeois *and* Les Pastorales. *All the stones in this series are numbered, but the sequence is irregular; this is explained by the fact that each week Daumier sent in four or six stones, to which he gave consecutive numbers, thus enabling him to calculate more easily the amount of work he had submitted to the paper. Daumier, therefore, produced these plates precisely when he was asked to. The first five which appeared on March 21, 23, 24 and April 11 and 17, all have roughly consecutive numbers, between 738 and 744. We may assume that the first stone he made, No. 737, entitled* La Contrainte par corps, *was not accepted by Philipon, who preferred instead to open the series with stone No. 744,* Lawyer and his Client.

Examination of the Registre du Dépôt légal of the Cabinet des Estampes reveals that the first 15 plates were deposited in the very month they appeared in Le Charivari, *probably a few days before they were due to be published. Nevertheless, Plate 16 was deposited in December 1845 but only appeared in January 1846, while No. 17, although deposited in January 1846, was not published until March. Thereafter, the gap between deposition and publication increased (for instance, No. 30, deposited in June 1847, appeared in August, while No. 35, deposited on January 3, 1848, appeared in April). From the same source we learn that the two plates, Nos. 39 and 26, discussed in the first heading, were deposited in May 1849 and in October 1846 respectively. Since they were never published in* Le Charivari, *their date of origin had until now been a mystery.*

Finally, it may be mentioned that the paper never collected these plates in an album, as had been done for other series, such as that devoted to Robert Macaire. This fact gives an added interest to the collection which is now offered to the public in the present volume.

As a general rule, the lithographs in the series Lawyers and Justice *have only two states, one before the text has been added, including the caption, the latter being the version published in* Le Charivari.

However, six of the plates (L.D. 1341, 1346, 1359, 1367, 1372) exist in three states rather than two, the intermediate state containing spelling mistakes, omissions of punctuation or other errors, which were rectified in the third state, the one printed in the paper. It was no doubt this final state which was submitted to Philipon and to Daumier himself, and also of course to the censor.[1]

1. Madame Fromrich, associated with the Cabinet des Estampes, collected material which proved invaluable in writing this note and drawing up the catalogue of plates.

Catalogue of the Plates

I. — LAWYERS AND JUSTICE (38 numbered plates).

1. *Beaten, Sir . . . beaten on all counts . . .*
 March 21, 1845[1] — L. Delteil, No. 1337. — Delteil mentions three states.

2. *Taken possession of, item . . . one water jug, containing no water . . .*
 March 23, 1845. — L. Delteil, No. 1338. — Delteil mentions two states.

3. *No close season for this sort of game.*
 March 24-25, 1845. — L. Delteil, No. 1339. — Delteil mentions two states.
 Daumier is portrayed on the left.

4. *The Court, having weighed the evidence . . .*
 April 11, 1845. — L. Delteil, No. 1340. — Delteil mentions two states.
 Here Daumier is really interested only in the two figures in the foreground, the one on the right recalling the faces of certain fish-men drawn by Grandville.

5. *Can you prepare a letter that will soften his heart? . . .*
 April 17, 1845. — L. Delteil, No. 1341. — Delteil mentions three states.

6. *A lawyer who is evidently profoundly convinced . . .*
 April 24, 1845. — L. Delteil, No. 1342. — Delteil mentions two states.

7. *Come, come, my dear colleagues . . .*
 April 24, 1845. — L. Delteil, No. 1343. — Delteil mentions two states.
 A group of three lawyers to be compared with L.D. 1545.

8. *I really gave you a good dressing down . . .*
 April 29, 1845. — L. Delteil, No. 1344. — Delteil mentions two states.

1. The date indicated is that of publication in *Le Charivari.* The numbers are those of the series until No. 38. After the 38 plates of *Lawyers and Justice,* the single and unpublished plates as well as the four plates entitled *Lawyers and Litigants* were numbered from 39 to 48.

9. *You insulted me in your address to the Court*
 May 2, 1845. — L. Delteil, No. 1345. — Delteil mentions two states.

10. *. . . and, in addressing the defendant's alleged Concierge . . .*
 July 29, 1845. — L. Delteil, No. 1346. — Delteil mentions three states.

11. *Yes, they would plunder this orphan . . .*
 August 15, 1845. — L. Delteil, No. 1347. — Delteil mentions two states.
 The judges' attitude is seen again in certain watercolours (Fuchs, 188*a* anc 189*b*).

12. *That makes three defendants on whom I couldn't make the charges stick . . .*
 August 21, 1845. — L. Delteil, No. 1348. — Delteil mentions two states.

13. *My dear fellow, we were unfortunate, that's all . . .*
 September 21, 1845. — L. Delteil, No. 1349. — Delteil mentions two states.
 The lawyer with a sharp nose is seen again in the watercolour formerly in the Bureau Collection (Fuchs, 182*b*).

14. *Well, my dear colleague, today you will be pleading against me . . .*
 October 13, 1845. — L. Delteil, No. 1350. — Delteil mentions two states.

15. *You were hungry . . . you were hungry . . .*
 October 20, 1845. — L. Delteil, No. 1351. — Delteil mentions two states.

16. *Defense Council compliments the Public Prosecutor . . .*
 January 8, 1846. — L. Delteil, No. 1352. — Delteil mentions two states.

17. *Come now, witness, it is important that you give us exact details of how you spent the 12th of April last . . .*
 March 4, 1846. — L. Delteil, No. 1353. — Delteil mentions two states.

18. *Lawyer Smug reading in a legal quarterly a eulogy of himself written by . . . himself . . .*
 March 26, 1846. — L. Delteil, No. 1354. — Delteil mentions two states.
 The aspect of the self satisfied lawyer may be compared to several contemporary plates of the *Bons Bourgeois*.

19. *What worries is that I am charged with twelve thefts . . .*
 June 20, 1846. — L. Delteil, No. 1355. — Delteil mentions two states.
 In the L.D. 1373 Daumier shows a lawyer dressed in his robe leaving a cell after visiting a prisoner.

20. *My dear Sir, it is quite impossible for me to take on your case . . .*
 August 6, 1846. — L. Delteil, No. 1356. — Delteil mentions two states.
 This attitude of the conceited lawyer, one of many, may be compared to the watercolour attributed to Daumier (Fuchs, 205*b*).

21. *The Public Prosecutor has just said some most unpleasant things about you* . . .
 August 24, 1846. — L. Delteil, No. 1357. — Delteil mentions two states.
 Daumier used the theme of the lawyer whispering to his client in a pen drawing (dating from about 1864) now in the Victoria and Albert Museum, London (Fuchs, 202*a*).

22. *He defends the widow and the orphan* . . .
 September 1, 1846. — L. Delteil, No. 1358. — Delteil mentions two states.

23. *At the café d' Aguesseau* . . .
 September 29, 1846. — L. Delteil, No. 1359. — Delteil mentions three states.

24. *What a pity that lovely little lady didn't confide her case to me* . . .
 October 14, 1846. — L. Delteil, No. 1360. — Delteil mentions two states.
 Some of the figures are found again in the watercolour, *Le Tribunal* (Fuchs, 316). The figure of the woman with her back turned to us can be compared to that shown in one of the plates of the *Types Parisiens* of 1839.

25. *The judge of the reconciliation court has given his judgement* . . .
 October 24, 1846. — L. Delteil, No. 1361. — Delteil mentions two states.

26. *A dissatisfied plaintiff.*
 1846. — L. Delteil, No. 1362. — Delteil mentions two states.
 This plate was not published in *Le Charivari*. It was acquired in October 1846 by the Cabinet des Estampes of the Bibliothèque Nationale.

27. *A defense lawyer discussing business matters at his usual office.*
 November 1, 1846. — L. Delteil, No. 1363. — Delteil mentions two states.

28. *So even if I admit* . . .
 November 11, 1846. — L. Delteil, No. 1364. — Delteil mentions two states.
 To be compared to the lithograph L.D. No. 1355: 'What worries me . . .' (Plate 19).

29. *Take him to Court* . . . *that would be a good trick to play on your neighbour* . . .
 November 18, 1846. — L. Delteil, No. 1365. — Delteil mentions two states.
 Another contrast of a man dressed in black facing one dressed in white. Daumier is familiar with the greedy face of the country lawyer and it is found again in L.D. plates 1364 and 1367.

30. *The lawyer who does not feel well* . . .
 August 19, 1847. — L. Delteil, No. 1366. — Delteil mentions two states.
 Daumier has already emphasized the lawyer's theatrical fainting spell. 'You fainted wonderfully, my dear fellow' (L.D. 486).

31. *Should be a good performance today, Mr Galuchet . . .*
 September 8, 1847. — L. Delteil, No. 1367. — Delteil mentions three states.
 The concierge of the Palais de Justice is a type often seen in Daumier's work and we find him again in *A defense lawyer discussing business matters at his usual office* (Fuchs, No. 1363) and in *Take him to Court . . . that would be a good trick to play on your neighbour* (Fuchs, No. 1365). As for the lawyer, the type of fat, snub-nosed man, we find him in a drawing in the Claude Roger-Marx Collection (Fuchs, 318*a*).

32. *Never mind . . . let him say a few unpleasant things about you . . .*
 October 11, 1847. — L. Delteil, No. 1368. — Delteil mentions two states.

33. *An oration worthy of Demosthesnes.*
 November 1, 1847. — L. Delteil, No. 1369. — Delteil mentions two states.

34. *Case lost again in the Royal Court . . .*
 January 5, 1848. — L. Delteil, No. 1370. — Delteil mentions two states.
 The figure on the right is one of Daumier's self-portraits. The lawyer next to him has a very special type of face which is found again in a drawing entitled *A Good Idea* (Fuchs, 182*a*).

35. *It's true you lost your case . . .*
 April 27, 1848. — L. Delteil, No. 1371. — Delteil mentions two states.
 A painting in the former Cordey Collection at Éragny, *The Lost Trial* or *The Counsel for the Defense for the Widow and Orphan,* is an exact reproduction of this composition and was shown at the Daumier Exhibition in 1901 (No. 30 in the catalogue); it is now with a dealer in London (Fuchs, 19*b*).

36. *Main staircase of the Palace of Justice. Face on view.*
 February 8, 1848. — L. Delteil, No. 1372. — Delteil mentions three states.
 Daumier used this theme again in *The Two Lawyers* (Fuchs, 19*a*), a painting formerly in the Rouart Collection and now in the Musée de Lyon. It may also be compared to the drawing mentioned by Fuchs as No. 202*b*).

37. *It seems my customer is a real villain . . .*
 October 25, 1848. — L. Delteil, No. 1373. — Delteil mentions two states.
 In Plate No. 19 we see the lawyer inside the cell with the prisoner, whereas here he is leaving the cell.

38. *When crime doesn't pay.*
 October 31, 1848. — L. Delteil, No. 1374. — Delteil mentions two states.
 The figures in this lithograph may be compared to studies made about 1848 for *La Marche de Silène.* The same type is found again in Plate L.D. No. 1658 of the *Tout ce qu'on voudra* series.

II. — SEPARATE PLATE

39. *You are very pretty . . .*

1848. — L. Delteil, No. 1375. — Delteil mentions two states.

This plate did not appear in *Le Charivari* and was acquired by the Bibliothèque Nationale in May 1849. Doubtless it was never printed. There are moreover only a few rare proofs.

The theme of the lawyer and the young client was also used by Daumier in a watercolour (Fuchs, 196*a*), and in the following lithograph, the type of magistrate being similar.

III. — UNUSED AND UNPUBLISHED PLATES

40. *The Widow,* about 1846.

This lithograph was never published. There are two known prints, one in the Cabinet des Estampes and another in the Lessing J. Rosenwald Collection. The stone number (960) leads us to believe that the work dates from the fall of 1846, like the plate 25/25 of *Lawyers and Justice* which is No. 961.

Despite its beauty it was at once wiped off and No. 960 was given to the stone *A dissatisfied plaintiff,* No. 26 of the same series.

Thanks to a Rockefeller bequest, the print in the Cabinet des Estampes was acquired by Monsieur Maurice Gobin in 1931.

41. *The Beginner.*

L. Delteil, No. 1376.

There is only one known proof of this lithograph which, according to Delteil, was owned by Geoffroy-Dechaume. Once part of the Eugène Mutiaux Collection, it now belongs to Maître Maurice Loncle, by whose permission we have been able to reproduce it. It was not printed in *Le Charivari* probably because it strongly resembled other plates (the central figure is seen again in No. 1370) and perhaps because it is among the least satirical of the entire series.

42. *The Two Lawyers.*

L. Delteil, No. 1377.

There is only one known proof of this lithograph which had belonged to the Geoffroy-Dechaume Collection and is now in the Henri Thomas Collection. It may have been refused by *Le Charivari* for the same reasons as the previous plate. It has been compared to a drawing representing lawyers chatting (the former Bureau Collection, Fuchs, No. 182).

43. *The Consultation.*

There is only one known proof of this unpublished lithograph without text once part of the Geoffroy-Dechaume Collection and now owned by Maître Maurice Loncle. The number of the stone is 1103 which means that the lithograph was drawn in the fall of 1848, since No. 1104 (Plate 38 of the series) appeared in *Le Charivari* in October of that same year (See text of No. 38).

The newspaper probably refused this plate since it closely resembled No. 1, *Beaten, Sir* . . . The stone number 1103 was then given to Plate 52 of *Tout ce qu'on voudra* which appeared in January 1850.

As its owner well noticed, the composition may be compared to Plate No. 1 of *Lawyers and Litigants*. The work is reproduced here for the first time.

LAWYERS AND LITIGANTS

The four stones on which Daumier prepared the lithographs of these four plates are numbered as follows: plate one, No. 1326; plate two, No. 1094; plate three, No. 1081; plate four, No. 1063.

These stones numbers show that the plates published in 1851 were already engraved in 1848, for stone No. 1082 was printed on June 19, 1848 and stone No. 1325 on December 19, 1848.

Composed in 1848, all four plates complement the *Lawyers and Justice* series.

1. *The lawyer—The case is coming on nicely* . . .
 Le Charivari, November 12, 1851. — L. Delteil, No. 2185. — Delteil mentions two states. — Deposited at the Bibliothèque Nationale, November 7, 1851.

2. *Everyone has got clients except me* . . .
 Le Charivari, November 14, 1851. — L. Delteil, No. 2186. — Delteil mentions two states. — Deposited at the Bibliothèque Nationale, November 12, 1851.

3. *At last we have managed to obtain a partition of the wife's and the husband's property* . .
 Le Charivari, December 3, 1851. — L. Delteil, No. 2187. — Delteil mentions two states. — Deposited at the Bibliothèque Nationale, December 8, 1851.

4. *Don't forget to make a reply to my plea* . . .
 Le Charivari, December 22, 1851. — L. Delteil, No. 2188. — Delteil mentions two states. — Deposited at the Bibliothèque Nationale, December 19, 1851

The lithographs reproduced in this book were graciously placed at the publisher's disposal by Monsieur R. G. Michel.

THIS BOOK
WAS PRODUCED BY
ÉDITIONS ANDRÉ SAURET.
PRINTING WAS COMPLETED
IN JULY 1971 ON THE PRESSES OF
THE IMPRIMERIE DARANTIERE
AT DIJON.
THE REPRODUCTIONS OF THE LITHOGRAPHS
WERE PRINTED BY
THE IMPRIMERIE MODERNE DU LION
IN PARIS.